The Rape of the Masters

ROGER KIMBALL

The Rape
of the Masters

HOW POLITICAL CORRECTNESS

SABOTAGES ART

ENCOUNTER BOOKS
San Francisco

 ENCOUNTER BOOKS

First edition published in 2004 by Encounter Books, an activity of Encounter for Culture and Education, Inc., a nonprofit tax-exempt corporation.

Encounter Books website address: www.encounterbooks.com

Manufactured in the United States and printed on acid-free paper.

The paper used in this publication meets the minimum requirements of ANSI/NISO Z39.48-1992 (R 1997) (*Permanence of Paper*).

FIRST EDITION

Library of Congress Cataloging-in-Publication Data:
Kimball, Roger, 1953– .
 The rape of the masters : how political correctness sabotages art
 / Roger Kimball
 p. cm.
 Includes bibliographic references and index.
 ISBN 1-893554-86-4 (cloth : alk.)
 1. Politics in art. 2. Political correctness. I. Title.
N72.P6K54 2004
750'.1'1809045-dc22

 2004043343

10 9 8 7 6 5 4 3 2 1

To William F. Buckley, Jr.

πολλῶν οὕνεκα

Contents

List of Illustrations

Plates follow page 84.

1. Jean Désiré Gustave Courbet, French, 1819–1877
 The Quarry (La Curée), 1856
 Oil on canvas: 210.2 x 183.5 cm
 (82 3/4 x 72 1/4 in.)
 Museum of Fine Arts, Boston
 Henry Lillie Pierce Fund (18.620)

2. Mark Rothko, American, 1903–1970
 Untitled, 1953
 Mixed media on canvas, irregular: 269.24 x 129.22 cm
 (106 x 50 7/8 in.)
 Whitney Museum of American Art, New York
 Gift of the Mark Rothko Foundation (85.43.2)

3. John Singer Sargent, American, 1856–1925
 The Daughters of Edward Darley Boit, 1882
 Oil on canvas: 210.2 x 183.5 cm
 (82 3/4 x 72 1/4 in.)
 Museum of Fine Arts, Boston
 Gift of Mary Louisa Boit, Julia Overing Boit,
 Jane Hubbard Boit, and Florence D. Boit
 in memory of their father, Edward Darley Boit (19.124)

4. Peter Paul Rubens, 1577–1640
 Drunken Silenus, 1618
 Oil on oak: 205 x 211 cm
 Bayerische Staatsgemäldesammlungen,
 Alte Pinakothek, Munich (772)

5. Winslow Homer, American, 1836–1910
 The Gulf Stream, 1899
 Oil on canvas: 71.4 x 124.8 cm
 (28 1/8 x 49 1/8 in.)
 The Metropolitan Museum of Art, New York
 Catharine Lorillard Wolfe Collection, Wolfe Fund, 1906
 (06.1234)

6. Paul Gauguin, French, 1848–1903
 Spirit of the Dead Watching, 1892
 Oil on burlap mounted on canvas: 72.4 x 92.4 cm
 (28 1/2 x 35 3/8 in.)
 Albright-Knox Art Gallery, Buffalo, New York
 A. Conger Goodyear Collection, 1965

7. Vincent van Gogh, 1853–1890
 A Pair of Shoes, 1886
 Oil on canvas: 37.5 x 45 cm
 Van Gogh Museum (Vincent van Gogh Foundation),
 Amsterdam (F255)

8. Diego Rodriguez Velazquez, Spanish, 1599–1660
 Las Meninas, 1656
 Oil on canvas: 318 x 276 cm
 Museo del Prado, Madrid

A Note on Sources

As I was writing this book, I passed around draft chapters, sans notes and illustrations, to various friends. The question I was asked most often was "Are you making this up?" Given the preposterousness of much that I quote, it was a natural question. The answer, alas, is No, I did not make it up. I did not want to clutter the text with notes, but readers whose credulity is taxed can find the source and page number for all quotations by consulting the endnotes.

The Rape of the Masters

Introduction
The Rape of the Masters

HAMLET: *Do you see yonder cloud that's almost in shape of a camel?*
POLONIUS: *By th' mass and 'tis—like a camel indeed.*
HAMLET: *Methinks it is like a weasel.*
POLONIUS: *It is backed like a weasel.*
HAMLET: *Or like a whale.*
POLONIUS: *Very like a whale.*

[W]here art history is concerned, in the beginning was the eye, not the word.
—Otto Pächt *The Practice of Art History*, 1986

Everything is what it is, and not another thing.
—Bishop Butler, 1726

Reality check

WHY do we teach and study art history? It is a question that elicits a complicated answer. To learn about art, yes, but also to learn about the cultural setting in which art unfolds; in addition, to learn about—what to call it? "Evolution" is not quite right,

neither is "progress." Possibly "development": to learn about the development of art, then, about how over the course of history artists "solved problems"—for example, the problem of modeling three-dimensional space on an essentially two-dimensional plane.

Those are some of the answers, or some parts of the answer, most of us would give. There are others. We teach and study art history—as we teach and study literary history or political history or the history of science—partly to familiarize ourselves with humanity's adventure in time. We expect an educated person in the West to remember what happened in 1066, to know the plot of *Hamlet*, to understand (sort of) the law of gravity, to recognize the *Mona Lisa*, Botticelli's *Birth of Venus*, or Manet's *Bar at the Folies-Bergère*. These are aspects of a huge common inheritance, episodes that alternately bask in and cast illuminations and shadows, the interlocking illuminations and shadows that delineate mankind's conjuring with the world.

All this might be described as the dough, the ambient body of culture. The yeast is supplied by direct acquaintance with the subject of study: the poem or novel or play, the mental itinerary a Galileo or Newton traveled, the actual work of art on the wall. In the case of art history, the *raison d'être*—the ultimate motive—is supplied by a direct visual encounter with great works of art. Everything else is prolegomenon or afterthought: scaffolding to support the main event, which is not so much learning *about* art as it is experiencing art first hand.

Or so one might have thought. What has happened to the main event? Suppose you dropped into Art History 101 at your local college, haunted the annual

meeting of the College Art Association, trailed after a curator at the Whitney Museum of American Art, perused the major journals and new scholarly books devoted to art history: what would you discover? Doubtless a wide variety of things. Here and there, I am sure, you would find art history pursued as outlined above: as an educational endeavor concerned with genuine scholarship, an adventure in seeing, a collaboration that aimed above all at facilitating the direct encounter with important works of art. I want to stress this disclaimer. I do not say "I am sure" in the deflationary sense, meaning "perhaps, but probably not." I mean it rather in an affirmative, a declarative sense. I can instantly think of several art historians and curators who are deeply engaged with the aesthetic substance of art. I mention several such figures in the course of this book: critics and historians and connoisseurs who like art, who delight in *looking*, and who seek to communicate this passion and delight.

But that's the end of the good news. Because the dominant trend—the drift that receives the limelight, the prizes, the honors, the academic adulation—is decidedly elsewhere. Yes, there are dissenting voices. But the study of art history today is more and more about *displacing* art, subordinating it to "theory," to politics, to the critic's autobiography, to just about anything that allows one to dispense with the burden of experiencing art natively, on its own terms.

I'll come back to those quotation marks around the word "theory" below. For the moment, I want to underscore the nature of the attack on art. Here is what's happening: the study of art is increasingly being coopted by various extraneous, non-artistic, non-aes-

thetic campaigns. Instead of seeking to preserve the distinctive pulse of aesthetic achievement, art history is pressed into battle—a battle against racism, say, or traditional notions of aesthetic achievement; it is enlisted on behalf of some putatively disenfranchised group or made an accessory to one or another version of academic arcana in which the political can barely be disentangled from the metaphysical or (to be more strictly accurate) from the floridly linguistic.

To a large extent, what is happening in art history parallels what happened over the past few decades to the study of comparative literature and kindred humanistic disciplines. Connoisseurs of *that* disaster will recognize many of the same names, a similar vocabulary, a kindred minatory tone. One thinks, for example, of the glorified place accorded to the German critic Walter Benjamin (1892–1940), whose essay "The Work of Art in the Age of Mechanical Reproduction" has become a kind of sacred text in literary and art historical studies. Why? Because Benjamin, writing under the influence of the Frankfurt School Marxist Theodor Adorno, argued that advances in artistic reproduction—especially the advent of film—had shifted interest away from the art object and its "aura" of uniqueness and onto art as an instrument of political transformation. "The instant the criterion of authenticity ceases to be applicable to artistic production," Benjamin wrote, "the total function of art is reversed. Instead of being based on ritual, it begins to be based on another practice—politics."

What frissons of delight that statement produced! The extraordinary popularity of Benjamin's essay, for art historians no less than for literary theorists, lay

partly in its effort to dethrone the work of art (and by implication the artist) and partly in its overt call for "progressive" spirits to "politicize" art. In Benjamin's essay, grateful academics found the perfect rationalization of their efforts to subordinate the ostensible subject of their discipline to an agenda, to reduce art or literature to an alibi for . . . you can complete the ellipsis by consulting this week's list of modish causes.

In some respects, what has happened to art history is an old story. In *The Painted Word* (1975), Tom Wolfe amusingly exposed the tendency among the art elite of the 1970s to assume that "paintings and other works exist only to illustrate the text," i.e., the critical text that purported to reveal to us the "real" meaning of some trendy contemporary art. Wolfe imagined a big retrospective at the Museum of Modern Art in which the featured works would be huge blow-ups of passages from various influential critics, each illustrated by small reproductions of works by the artists discussed in the text, the discrepancy in size indicating the relative importance of the items. Whatever Wolfe may have missed about the art of the period ("modern art" was for him a term of opprobrium), he deliciously skewered some prevalent pomposities. It must also be said that the cautionary tale he offered about the art world of the time is if anything more pertinent today than it was in 1975.

Wolfe satirized a common propensity that had suddenly metastasized. The temptation to drown art in a sea of words is a critical *déformation professionelle*. Critics like the sound of their own words as much as they like the spectacle of their own learning. How convenient that works of art provide them with an oppor-

tunity to exhibit both! Sometimes ingenious critical commentary reveals something important about works of art; sometimes it is merely ingenious. The place of such criticism in the canon of scholarship can be high. One thinks, for example, of Erwin Panofsky (1892–1968) and his excursions into "iconology." Those essays are fun to read, full of interesting facts from literature, history, and philosophy. Occasionally they even say something directly about the aesthetic qualities of the work under discussion. Occasionally.

Panofsky was a scholar and humanist of rare talent and sensibility. If his writing often wandered pretty far from his ostensible subject, it was almost always illuminating in other ways. This is decidedly not the case with many academic art historians today. Moreover, it is worth noting the role played by laziness in much contemporary art history—laziness, I mean in seeing and feeling. Tremendous displays of scholarship are not incompatible with this fundamental laziness. Indeed, there is often an inverse relationship between the display of scholarship—what used to be called pedantry —and the effort of aesthetic intelligence. The labor of seeing can be largely avoided by the expedient application of verbal embroidery. Critics and scholars are adept—or practiced, anyway—at using words. The habit of *looking* requires different emotional and intellectual resources; and the task of communicating what one sees involves yet other skills. It is not surprising that art collects verbiage as the space under your bed collects dust kitties. In both cases there is a natural affinity at work.

But the phenomenon I am talking about, though it overlaps with other, more benign forms of distraction,

differs sharply in aim and effect from your run-of-the-mill scholarly cadenza or irrelevancy. It differs also from the kind of critical hubris that Tom Wolfe poked fun at, even though many of the verbal tics he discerned in the 1960s and 1970s are still with us. The crucial difference is an ideological difference. In a word, what we are witnessing today is the triumph of political correctness in art history. It's a pretty depressing prospect, not least because by subordinating art to a non-artistic agenda one drains art of its intrinsic dignity and pleasure. As I have argued elsewhere, political correctness operates by transposing life to an alien jurisdiction, presuming to judge our endeavors according to the peremptory diktats of self-proclaimed virtue. It is worth stressing that the chief issue, the chief loss, lies not in the particular program being espoused: the war on patriarchy, the struggle against capitalism, the march against "formalist values," "bourgeois ethics," or supposedly "outmoded" norms of representation. Whatever one thinks of those campaigns—love them or hate them—they all displace art, relegating it to the status of a prop in a drama not its own.

Strategies of subversion

The attack on art generally unfolds in one of two ways. The first involves a process of *spurious aggrandizement*. You hail the mediocre as a work of genius, for example, or pretend that what is merely repellent actually ennobles our understanding of art or life. If art is no longer to be judged primarily in terms of aesthetic achievement, it is vulnerable to usurpation by any

importunate bandwagon: the one marked "egalitarianism" just as much as the one marked "anarchy," "opportunistic nihilism," or "fatuous revolutionary politics."

One of the most insidious expressions of this process of *de bas en haut* involves a travesty of traditional aesthetic judgment. One thinks, for example, of Robert Mapplethorpe's photographs of the sadomasochistic demimonde and those cheerleaders who pretended to admire them for their formal excellence: the exquisite triangulation of the bullwhip being reminiscent of the composition of certain classical nudes, etc., etc. Or consider the London-based artists Gilbert and George. When they exhibited *The Naked Shit Pictures*—huge photo-montages of themselves naked with bits of excrement floating about—one critic invoked the Isenheim altarpiece as a precedent, while another spoke of the artists' "self-sacrifice for a higher cause, which is purposely moral and indeed Christian." You can almost hear these critics sneer: "You want aesthetic appreciation? We'll give you aesthetic appreciation—of garbage." In part, this is a strategy of what I have elsewhere called "the trivialization of outrage." The vocabulary of aesthetic delectation is reforged into a demonic parody of itself. The moral is that art is no more immune to perversion than any other realm of human endeavor.

Spurious aggrandizement describes one strategy in the war against art. It blurs the distinction between high and low, elevating the detritus of popular culture to the status of fine art. (The mot, variously attributed to Andy Warhol and Marshall McLuhan, that "Art is what you can get away with" sums up the governing

attitude.) The second main strategy, *the rape of the masters*, proceeds in the opposite direction. It operates not by inflating the trivial, the mediocre, the perverse, but by attacking, diluting, or otherwise subverting greatness. Its enemy is civilization and the social, moral, and aesthetic assumptions upon which civilization rests. Its aim is to transform art into an ally in the campaign of *de*civilization.

Sometimes the assault is direct: Marcel Duchamp places a moustache on the upper lip of a reproduction of the Mona Lisa, thus signalling his contempt for the whole enterprise of art as traditionally understood. Duchamp endeavored to explode the whole category of aesthetic achievement. He hoped that Dada would spell the end of art as traditionally understood. It didn't happen. But how many little Duchamps have you glimpsed scurrying around the contemporary art world? Duchamp took an ordinary snow shovel and exhibited it as a work of art. How daring! But that was 1915. He pulled the same trick with a urinal. How transgressive! But that was 1917. Duchamp started a cottage industry that is still going strong. But he and his Dadaist heirs, though impish, are at least direct. More often the attack on art proceeds by a strategy of indirection. The work of art is seized as an occasion for critical lucubration, for political sermonizing, for theoretical or pseudo-theoretical exegesis. (It is worth noting that Duchamp, whatever his intentions, has also inspired plenty of exegesis.) Here, too, there is an element of spurious aggrandizement—of the interpreter. But for the work of art, the result is a despoliation, a rape.

In "The Authorship of *In Memoriam*," the English

essayist Ronald Knox "proved" that the real author of that familiar poem was not Alfred, Lord Tennyson, as many of us have supposed, but Queen Victoria. Knox's essay is a delightful *jeu d'esprit*, an amusing poke at the poor souls who believe that Francis Bacon or some other Elizabethan worthy wrote the plays commonly attributed to William Shakespeare. But Knox wrote with tongue in cheek. His essay is funny because it is meant as satire. Those academics who undertake the rape of the masters might be funny were they not in earnest. But earnest they are. They write to traduce, not satirize. More precisely, they poach upon the authority of art in order to pursue an entirely non-artistic agenda. Their interest in art is ulterior, not aesthetic.

The theoretical impasse

Anyone who has been out on a bright summer day and ducks quickly into a room with the shades lowered knows that it takes the eyes a while to adjust. Just so, anyone used to the calm sunshine of rational discourse is likely to be disoriented at first by the tenebrous musings that populate the discipline of academic art history today. It seems unfair to plunge directly into these stygian shallows without a preliminary acclimatization. I can think of no better *hors d'oeuvre* than a brief introduction to the term "theory."

If there were a Society for the Prevention of Cruelty to Words, "theory" would long ago have been granted protected status as an Abused Noun. Academics wishing to use the word would be required to apply for a special license, submit character references from three

persons never convicted of exposure to graduate-school education, and contribute to a fund for other unfortunate words. The case of "theory" is especially sad, because in it we have an example of serial abuse: first by the professors of literature, then the professors of "cultural studies" and kindred interdisciplinary redoubts, and lately by art historians.

"Theory" has a complicated history. It derives from a Greek word meaning "to look at, behold." "Theory" in this sense implies a certain passivity on the part of the beholder: a theory gave us access not to something we *made* but to something we *received* when properly attentive. Today, however, we use "theory" in a sense close to the opposite of this etymological meaning. A "theory" nowadays is not so much what we see or behold as a mental scaffolding we imagine or project in order to account for what we see or behold. In short, theory, which once betokened an attunement or congruence with reality, now signifies a wilful imposition.

Still, in normal parlance, "theory" remains a perfectly respectable word. It has plenty of legitimate colloquial uses: "I have a theory about that," someone says, meaning that he has idea about what happened and why. We also regularly distinguish between theory—the way things are supposed to happen—and practice—the way they in fact do happen (the idea being that there is often a disjunction between the two). "That's all very well in theory," you say, meaning that in practice things are likely to turn out rather differently.

We also use "theory" in a more formal sense, meaning, as *The American Heritage Dictionary* explains,

Systematically organized knowledge applicable in a

relatively wide variety of circumstances, esp. a system of assumptions, accepted principles, and rules of procedure devised to analyze, predict, or otherwise explain the nature or behavior of a specified set of phenomena.

"Theory" in this sense is part of the drama of rational inquiry. A theory is not just idle speculation but a carefully formulated set of hypotheses offered as a possible explanation of something. A theory has a tentative or adventurous side—it advances beyond the facts in its effort to explain them—but its legitimacy is measured primarily by its honesty and allegiance to the truth.

The truth? You can almost feel the shudder of horror cascading through the professoriate: imagine someone so naïve as to speak of "the truth"! They don't do truth in the fashionable precincts of the academy today. They do "theory." You even encounter people who use "theorize" as a transitive verb: "So-and-so theorizes the idea of freedom" (or art, nature, cookery, whatever), meaning that So-and-so embellishes whatever it is with a skein of owlish verbal irrelevancies. "Truth" is rarely spoken of, and then only in deprecatory scare quotes.

Have you noticed how widespread is the use of those instruments of epistemic deflation? It is positively epidemic. And why not? A simpler method of neutralizing or ironizing meaning can hardly be imagined.* Never speak of virtue when you can say "virtue"; a bit of reasoning is not logical, but only "logical"; the procedure in question is not sound, but merely "sound."

* On this use of scare quotes, see David Stove's brilliant essay "Neutralizing Success Words" in his book *Scientific Irrationalism: Origins of a Postmodern Cult* (New Brunswick: Transaction, 2001), pages 21–48.

14

And so on. It works with words of cognitive failure, too: don't say that an argument is refuted, only that is "refuted." To appreciate what is at stake, consider the difference between fresh fish and "fresh" fish: the difference is difficult to define, perhaps, but easy to smell. The marvelous thing about this use of scare quotes is that it allows you to insinuate doubt without positively asserting anything at all. You don't declare that "X" is *not* true, merely that "X is 'true.'"

"Theory" in the fashionable new sense is scarcely imaginable without such weapons of semantic sabotage. And this was only to be expected. For theory as practiced in the academy today is primarily an instrument of politics, not inquiry. It is meant to insinuate a subplot of unacknowledged motives behind every declaration. When you hear—as you are always hearing these days—someone say that truth is "socially constructed," that "knowledge is a function of power," etc., it is a good bet that in the next sentence he is going to offer you a dollop of "theory" to support his claim.

What sort of theory? People who go in for this sort of thing are fond of asserting that "everything is political," meaning that the ideal of disinterested inquiry is little more than a charade. How could it be otherwise, they argue, since all our acts are by definition *our* acts, i.e., self-interested?

Thinkers at least as far back as Joseph, Bishop Butler (1692–1752) have exposed the confusion that lies behind the "strange affection in many people of explaining away all particular affections, and representing the whole of life as nothing but one continued exercise in self-love." There are three main sources feeding the

confusion. The emotional or characterological source is programmatic cynicism. The notion that selfishness is universal and unremitting is as much a matter of temperament as conviction. The idea appeals especially to those clever people who view every ideal as a blind, every value as a rationalization of some interest.

The second source of the confusion is a common but fatal logical solecism, namely the tendency to milk tautological premises for real-life conclusions. The Australian philosopher David Stove (1927–1994) drew on Butler's classic argument when he pointed out that the "everything-is-political, all-acts-are-self-interested" attitude, though positively *de rigueur* among trendy academics today, rests on this fundamental logical mistake. As Stove observes,

> It plainly does not follow from the tautology, "No man can act intentionally except from some interest which he has," that "No man can act intentionally except from motives of self-interest." That inference belongs to exactly the same class as the atrocious (though ever popular) inference from "Whatever will be, will be," to "All human effort is ineffectual." . . . If you set out from a tautological premise you cannot validly infer from it *any* conclusion which is not itself tautological.
>
> The possible objects of a man's interests, motives, or desires, are inexhaustibly various. Among them may be, to wreck revenge on a particular man, to gain the love of a particular woman, to serve his country, to experience the love of God, to understand contemporary physics . . . the list is endless. But it can perfectly well happen, and often does happen, that a man pursues

one or more of these "particular" passions without re-
gard to his own interests.

As Butler himself put it, "It is not because we love our-
selves that we find delight in such and such objects, but
because we have particular affections towards them.
. . . Everything is what it is, and not another thing."
Would that this observation could be inscribed over the
portals of our departments of literature and art history.

The third main source of the conviction that "every-
thing is political" and that truth is culpably under-
dressed unless it appears in deflationary scare quotes is
that curiously popular form of epistemological gloom-
iness that Stove calls "cognitive Calvinism." "Cal-
vinists," Stove observes,

> believe in the total depravity of human nature: if an
> impulse is one of ours, it is bad, *because* it is one of
> ours. The argument,
>
> > Our knowledge is our knowledge,
> > So,
> > It is not knowledge of real things,
>
> could seem valid only to someone who felt that any
> knowledge *we* have could not be the real thing, *be-
> cause* we have it.

With typical insouciance, Stove once organized a com-
petition to find and publicize "the worst argument in
the world." The winning submission, Stove explained,
would be distinguished not only by its intrinsic awful-
ness but also by its degree of acceptance among philo-
sophers and the extent to which it had escaped criti-

cism. In the event, Stove decided to give the palm to the family of arguments that he had contributed to the competition himself—arguments that will be horribly familiar to anyone who has studied philosophy:

> We can know things only:
> • as they are related to us
> • under our forms of perception and understanding
> • insofar as they fall under our conceptual schemes
> • etc.,
> So,
> We cannot know things as they are in themselves.

As Stove points out, one might just as well argue for "gastronomic idealism" along the following lines:

> We cannot eat oysters as they are in themselves,
> Because
> We can eat oysters only insofar as they are brought under the physiological and chemical conditions which are the presuppositions of the possibility of being eaten.

Stove's criticisms of "cognitive Calvinism" and the arguments supporting it occur in an essay attacking idealism. But it is important to note that the arguments he attacks are by no means propounded only by idealists. Indeed, in one version or another, such reasoning, as Stove points out, "is common to all the main varieties of cognophobe who now make up the staff of the faculties of arts in Western universities; and none of these is idealistic, even by implication."

A Woolworth deconstructionist

OK, OK, but what does all this have to do with art history? Well might you ask. For a first answer, let's turn to Keith Moxey, the Ann Whitney Olin Professor of Art History at Barnard College and Columbia University. Professor Moxey is only a minor star in the academic firmament. But he glows with a wholly characteristic—not to say utterly predictable—light. His books—there were about half a dozen at last count— are a compendium of fashionable academic clichés both in attitude (polysyllabic leftism) and in argument (off-the-rack items from the lexicon of deconstruction).

In short, Professor Moxey is a sort of five-and-dime deconstructionist, recapitulating all the standard postmodernist arguments as a music box plays its repertoire of tunes: mechanically, with a distinct lack of sonority, but also with no wrong notes. Which is why his work provides such a good introduction to the temperament, the intellectual weather, of contemporary art history: there are no surprises—just pages and pages of received ideas, neatly arranged, undisturbed by anything resembling a doubt, scruple, or hesitation.

Especially pertinent for our purpose is Professor Moxey's book *The Practice of Theory: Poststructuralism, Cultural Politics, and Art History* (1994). Professor Moxey has two basic contentions in this book. You can already guess what they are. Yes: one is that no "cultural practice"—the writing of history, for example—can be understood "without reference to theory." And the second is that "All cultural practice is shaped by political considerations." It's not a matter of "Where have you heard that before?" but "Where have you not?"

People who are new to this mode of argument might be tempted to ask, with respect to the first contention, precisely what *theory* is necessary to understand, say, Caesar's commentaries on the war in Gaul or Gibbon's *Decline and Fall of the Roman Empire*. Those are indubitably examples of "cultural practice" (let's cut to the chase and call it by its old name, "history"). People have been reading and understanding Caesar and Gibbon (for example) for many, many years, without even a soupçon of theory. Or have they? Perhaps people have been deluded from time immemorial and only now, fifteen minutes ago when the Age of Theory dawned, have they come to understand these (and all other) authors? What do *you* think?

Professor Moxey's book raises other questions, too. For example, with respect to the second contention, one might ask exactly what "political considerations" impinge upon the study of calculus, say, or the writing of lyric poetry, or, indeed, the painting or interpretation of pictures? Between us, Professor Moxey has no good answers to these embarrassing questions—which is not surprising because there are no good answers to them. But even to ask such questions shows that you are insufficiently attuned to the theoretical Weltanschauung Professor Moxey recommends. Read on and you will see how pointless it is to object. "Derrida has shown" —doesn't your heart leap up at that phrase?—

Derrida has shown that language is incapable of conveying the type of meaning that is usually ascribed to historical narratives. According to Derrida, linguistic signs are arbitrary constructs whose significance is impermanent and unstable. Language functions to suggest

an absent presence of meaning. That is, the meanings of linguistic representations are always illusory, since they depend on metaphysical claims that cannot be substantiated.

It would make an instructive—but also a very long—parlor game to enumerate all the things that have gone wrong in these few sentences. One might begin by asking in what sense Derrida can be said to have "shown" anything about the subject at hand. "Argued," possibly; "contended," no doubt. But "shown"? That word carries with it an implication of cognitive success. But has Derrida succeeded in demonstrating that "language is incapable of conveying the type of meaning that is usually ascribed to historical narratives"?

Think about that. The "type of meaning . . . usually ascribed to historical narratives" is contingent truth, as in the statement "Caesar crossed the Rubicon in 49 B.C." If Professor Moxey were right, then Derrida would have shown that such statements are "arbitrary constructs." But of course he showed no such thing, for the simple reason that such statements are not "arbitrary constructs" but true or false depending upon the facts of the case. (Here's another "linguistic sign": "This bottle contains aspirin." What if it contained arsenic instead? If Derrida had really shown that linguistic signs were "arbitrary constructs," he could have no grounds to complain about false advertising when he swallowed the contents.) How about the assertion that "the meanings of linguistic representations are always illusory"? Either it is false, in which case we can have done with it, or it is true—in which case it is, once again, false, because it contradicts itself. Oh dear.

Professor Moxey believes that he can side-step such difficulties (actually, they are refutations, but let that pass) by the clever expedient of giving up on truth.

> Only if it is possible to get it right, to find the "truth," can we have criteria by which to choose between alternative interpretations. If we claim there is no truth to be found, then we cannot be accused of not having a means of establishing what the truth might be.

But you might, Professor, be open to other accusations. We've already touched on the issue of self-contradiction. Take the claim "there is no truth to be found"—is that statement true? We've seen what follows if it is. And you might also, Professor, be open to the accusation of disingenuousness, preening self-importance, and a settled unwillingness to be (in Hume's phrase) a "candid" reasoner. For if you were right, there could be no reason to prefer your interpretation over anyone else's since *ex hypothesi* there are no criteria "by which to choose" one interpretation over another. (It is also worth pointing out that criteria needn't be exhaustive to be useful: we often can discriminate between better and worse descriptions of something without necessarily having access to a perfect description.)

Of course, Professor Moxey doesn't really believe that there are no criteria to which we can appeal in preferring one description to another. He clearly has *his* preferences, and he has easily enumerated reasons for his preferences. It's just that they are not *intellectual* or *aesthetic* reasons. Like his masters Jacques Derrida and Michel Foucault, Professor Moxey pretends that basic mental hygiene—beginning with a respect for

evidence and sound reasoning—is unimportant. What matters is politics—plus a measure of self-aggrandizement—not truth. So his "criteria" are simply political desiderata. "The abandonment of an epistemological foundation for art history," writes the Ann Whitney Olin Professor of Art History at Barnard College and Columbia University, means that "historical arguments will be evaluated according to how well they coincide with our political convictions and cultural attitudes." How about his students' art history papers? Are they, too, "evaluated according to how well they coincide" with Professor Moxey's "political convictions and cultural attitudes"? How could it be otherwise, if Professor Moxey is right? It's something that parents may wish to ponder as they make out their tuition checks.

The bottom line: since we no longer care about truth (that's what Professor Moxey means by abandoning an "epistemological foundation"), we can accept or reject arguments solely on the basis of whether they accord with our political interests. It follows that art history —like all forms of "cultural practice"—is at bottom "a form of political intervention" that takes part in "the processes of cultural transformation which characterize our society."

Now political intervention can be a good thing, it can be a bad thing. It depends, obviously, on the nature of the particular intervention. But is political intervention, be it ever so beneficent, something with which our professors of art history should concern themselves in their capacity as professors of art history, i.e., as teachers and scholars?

It is also worth asking exactly what sort of politics Professor Moxey advocates. As it happens, it is in

answering this—or, rather, in assiduously failing to answer it—that he for once demonstrates some moxie. For although Professor Moxey early and often indicates his distaste for "conservatives," he is impishly evasive when it comes to spelling out what sort of "political intervention" he favors. He calls for "a politically committed form of art historical interpretation," but says almost nothing about the nature of that commitment beyond "recognizing that politics is concerned with issues of race, class, and gender." Since political fashions change quite rapidly, Professor Moxey's vagueness is prudent. Clearly he is "on the Left," hence the mantra about "race, class, and gender." But that is hardly more than an empty shibboleth, a bit of ideological flag-waving. Professor Moxey's call for a "politically committed" art history that leaves the nature of the commitment unspecified and the very possibility of history in doubt may be intellectually fatuous, but it is politically cunning, for it enables him to absorb many minor adjustments in political orientation without ceasing to be "cutting edge."

But what does it all add up to? What does a "politically committed" "practice of theory" look like in action? Well, Professor Moxey does get around to some art in his book. For example, a chapter called "Making 'Genius'" (don't you love the scare quotes?) purports to deal with *The Garden of Earthly Delights* (c. 1504), the famous phantasmagorical triptych by Hieronymous Bosch (c. 1450–1516). In essence, Professor Moxey argues that Bosch was deliberately obscure and fanciful because that was the best way to appeal to his elite patrons and establish his reputation

as an artist. Professor Moxey doesn't put it like that, of course. Such plain language is insufficiently vertiginous for someone in the business of "practicing theory." Here is what Professor Moxey says about his approach to Bosch's painting:

> Instead of valuing transparency, by which paintings are said to offer us access to an intellectual realm behind the surface, I should like to emphasize opacity, their insistence that the interpreter create meaning before them. . . . I should like to call on Michel Foucault, who writes . . .

Well, you know what Foucault writes, near enough, so let Professor Moxey continue. In the next paragraph he introduces Ferdinand de Saussure and "a notion of the sign developed in the Soviet reaction to Saussure by Valentin Volosinov and Mikhail Bakhtin," among other tidbits. Then this:

> To suggest that signs may be ascribed specific meaning is not, of course, to suggest that they are univocal or that the interpreter can ever arrive at the "true" significance of the sign systems of the past. Instead, a recognition that signs are defined by their social and historical location implies that every interpretation is itself constituted by sign systems that have their own social and historical specificity. In other words, an understanding of the signifying processes of the past involves a recognition that the work of the interpreter is also a signifying process and that both the signs of the past and the sign of the present are colored and compromised by the circumstances of their production.

And so on for another thirty pages. The idea that language is futile is at the heart of the deconstructionist enterprise: this sort of writing makes it seem almost plausible. Consider Professor Moxey's lead up to the contention that "'genius' is a socially constructed category."

> Whether or not the artist can escape commodification in an art market organized on capitalist principles remains uncertain. . . . Nevertheless, the assertion of the autonomous power of the artist has increasingly been called into question as a legitimate ambition for artistic production. . . . A historical moment concerned with the dissolution of transcendent notions of creativity enables us to appreciate how this idea was first inscribed in the work of art in the period of the Renaissance. . . .

Et very much *cetera*. A dash of neo-Marxist rhetoric ("commodification," "capitalist principles"), a pinch of anachronistic skepticism: stir briskly and, voilà, even Hieronymous Bosch comes out looking like Professor Keith Moxey.

What should we think of Professor Moxey's effort to transform Bosch into a twenty-first-century postmodernist? We should think badly of it. Why? For one thing, because it leaves poor Bosch far behind—or, rather, it propels him forward to the ivy-covered walls of contemporary academia. If Professor Moxey is right, Bosch "ensured himself a place in the canon of 'great' artists admired by the Burgundian aristocracy and the humanistically educated upper classes" not by painting well but by a species of class-warfare game-playing. As

an interpretation of Bosch it is, to speak plainly, bosh. But as a way of helping Professor Moxey ensure his own place as a "brilliant" "scholar" in a "great" contemporary university, the procedure obviously has much to recommend it.

There is something unutterably depressing about wading through this sort of academic gobbledegook. It's not just the rebarbative pseudo-thought, the clichéd political sloganeering, the minatory, all-knowing tone. That's bad enough. But the real tragedy of this reader-proof verbiage is that it acts as a prophylactic, effectively sealing off students from any direct contact with works of art. Professor Moxey's aria about *The Garden of Earthly Delights* is only incidentally about the painting of that name. Its real subject is Professor Moxey's political obsessions—an absorbing topic to some, no doubt, but not particularly relevant to someone interested in Hieronymous Bosch.

Fighting back

The Rape of the Masters offers a counterattack to the view that art history is at bottom "a form of political intervention." Its purpose might best be described as medicinal: to provide an antidote—or at least an alternative—to the poison that has infiltrated the study of art history. As with all medicinal intervention, accurate diagnosis is a precondition of effective treatment. In part, then, this book may be considered a sort of *nosology*, a classification of diseases. By their nature, diseases are unlovely things. But I assume, Dear Reader, that you are a hearty soul, that you can abide a

largish dose of absurdity. So be forewarned. In the chapters that follow, I am going to quote a number of distasteful things: critics whose English is bad, whose diction is pretentious, whose arguments are preposterous. Would that I could avoid it. But it cannot be helped. To write honestly about the world of academic art history today is to enter a kind of madhouse.

There are, however, some precautionary measures worth taking. Perhaps the most important has to do with the attitude one brings to the subject. It is easy to be repelled or otherwise irritated by much of what goes forward under the name of art history today. The more one cares about the life of art, the more likely one is to be outraged. Outrage has its place, but a steady diet of outrage is tiring. It should be husbanded for special occasions. Laughter is a more beguiling activity. I am pleased to report that much of what I will put before you here affords, when looked at from the appropriate perspective, considerable value as a source of amusement, albeit unintended. After all, the unfolding of human folly has ever been a source of diversion.

I also hope that this book will have a certain apotropaic value. If you were foraging in the woods, you might decide to bring along a manual identifying toxic mushrooms. Just so, you may find it profitable to bring along *The Rape of the Masters* as you pick your way through the underbrush of contemporary academic art history. The book will, I hope, help you to identify and avoid many an academic amanita and false morel.

I must confess that "method" is a word I dislike almost as much as I dislike its polysyllabic alternative, "methodology." But, largely for reasons of compas-

sion, I did give considerable thought to how I might best present the material in this book. In essence, I have decided on a procedure of show and tell. In each chapter, I focus on a familiar painting that has, in one way or another, been seriously traduced by a prominent academic critic. The work in question is illustrated in the selection of plates after page 84. I describe, with an abundance of quotations, just how the work has been violated. Along the way, I provide my own account of the work that aims to respect its context, integrity, and aesthetic substance.

My tone, as befits my subject, is polemical; I seek to call attention to, not find excuses for, the critical depredations I describe. I offer arguments when arguments might help make a point. But by design there is as much ridicule as there is argument in this book. As Nietzsche once observed, one does not "refute a sickness," one *resists* it. In the face of blatant absurdity, ridicule is generally a more effective specific than argument. Condign ridicule can have a two-fold salubrious effect, chastening the object of ridicule while offering a gratifying catharsis for those who enjoy the spectacle. Similarly, common sense often provides more relief than a patient marshalling of reasons. When someone tells you that the moon is made of green cheese, you don't argue about it, you just put the chap down as a crackpot and move on. As readers make their way through this book, I hope that they will often turn to the plates to compare what is said about a particular work of art with what—if I may so put it—it says about itself.

As I set out to choose the works for *The Rape of the Masters*, I faced some hard choices. I wanted to show

that the disease is endemic, but I was keenly aware that anything like a full inventory of what has happened to art history would probably be actionable as cruel and unusual punishment. It would certainly make for a very long book. But concentrating on just two or three examples, however heinous and representative, would fail to give readers an accurate sense of the extent of the damage. On the one hand, I wanted to be sure that readers could not say, "But surely what you describe is the exception, not the rule, in art history." On the other hand, I felt some responsibility to look after my readers' stomachs—and take into account their patience. In the end, I decided to focus on seven paintings—one for every day of the week, as it were—with sidelong glances at several others. Each featured painting differs markedly from the others; each has been violated in a distinctive way by a prominent critic or school of critics. Since the rape of the masters is an equal opportunity enterprise, I cover a lot of ground, discussing abstract works and realist works, twentieth-century works and seventeenth-century works, works from America and works from Europe. My choices are meant to be exemplary. That is, each describes not only an egregious but also an influential approach to violating works of art. And taken together, I believe, they offer a sort of Baedeker to this branch of intellectual futility.

What is to be done?

Once upon a time we turned to art history to open the door to art. More and more what we get is a *cordon insanitaire* preventing any first-hand contact with the

work. I do not, by the way, mean to suggest that a full understanding of works of art cannot involve all manner of cultural, social, and historical elements. Of course it can, and often does. But the animating center must remain the work itself. Otherwise, what we get is not art history but a species of autobiography or political sermonizing. This was something that the great Austrian scholar Otto Pächt (1902–1988) discerned with unusual clarity. In his book *Van Eyck and the Founders of Early Netherlandish Painting* (English translation, 1994), Pächt noted that

> As a historical discipline, the history of art can absorb stimuli from outside, from iconology, from cultural sociology, from the sociology of art, or from whatever fashionable follies the future may bring; but it can never allow them to define the work that it has to do. Its vital nerve is maimed, if ever it feels obliged to serve the ends of any political, religious or social idea whatever. Those who refer everything to external causality will never see or understand the workings of inner necessity; and social relevance in historical scholarship is a contradiction in terms. Scholarship can bow to no worldly authority, not even the best; it knows only one loyalty, to the commonwealth of minds.

It is likely that you haven't heard of Otto Pächt. I hadn't myself until recently. His emphasis on the centrality of the work of art is out of favor in the academy today. How could it be otherwise with a scholar who declared that "where art history is concerned, in the beginning was the eye, not the word." What a daring idea, to look at works of art instead of "theorizing" about them (or,

as they now say, "instead of theorizing them")! Pächt can help us answer Lenin's famous question—at least as it is applied to art history—"What is to be done?" The short answer is to return to the work of art. But how? "When we travel," Pächt noted in *The Practice of Art History* (English translation, 1999), "we first make sure we get on the right train. In art history, people tend not to do this—and then they are surprised when they find themselves at an impasse, or at the wrong destination." Art history has lost its way. The road to recovery begins with a frank acknowledgment of where we have gone wrong. In the pages that follow, I endeavor to provide a short guide to that itinerary.

Chapter 1
Psychoanalyzing Courbet

This quarry cries on havoc.
—Fortinbras, *Hamlet* v: ii

A straightforward realist?

YOU CAN PROBABLY recall several paintings by Gustave Courbet (1819–1877), the French artist who emerged as the leader of the Realist school of painting in the 1850s. Born in Ornans, a small town fifteen miles southeast of Besançon in the Loue Valley, Courbet was the son of a moderately prosperous farmer. It was the usual story. Régis Courbet, having made a small mark in the world, wanted his son to pursue a professional career. Gustave, always a rebellious spirit, dutifully tasted the law but insisted instead on art. "Since in everything and every place I must always be an exception to the general rule," he wrote home from college, "I shall take steps to follow my own destiny." There was a battle of wills, but, eventually, Régis relented. In 1841, Courbet moved to Paris to devote himself wholeheartedly to art. In short order,

he scandalized the artistic establishment with his deliberately unidealized paintings of ordinary workers (not to mention his deliberately unidealized treatment of alcohol and women), just as he scandalized the political establishment with his iconoclastic socialism.

The consequences of the first scandal were celebrity and success. The consequences of the second were less happy. Courbet's socialism was inspired partly by his own irascible temperament, partly by his provincial peasant roots, but above all by his friendship with the socialist-anarchist Pierre-Joseph Proudhon (1809–1865), remembered today chiefly for the declaration "property is theft." Courbet's politics remained predominantly a verbal affair until events catapulted him, briefly, into practical life. In 1871, when the Commune had its few-months run after France's defeat in the Franco-Prussian War, Courbet was elected to various committees, including one charged with protecting the artistic treasures of France (other members included Corot, Daumier, Manet, and Millet). He oversaw—the details remain a matter of dispute—the destruction of the Vendôme Column (a monument commemorating Napoleonic victories), an act for which he was arrested and imprisoned after the Restoration. Fined an enormous sum to reconstruct the column, Courbet managed to escape to Switzerland in 1873, where he spent the last, unhappy four years of his life.

Courbet was largely—I was going to say "self-taught," but that is not quite right. He didn't go in much for formal schooling of any kind. But he had many art teachers. He found them on the walls of the Louvre, in galleries in Holland, and, to a lesser extent, on his several visits to Germany in the early 1850s,

where he encountered the work of the Realist painter Adolf Menzel (1815–1905). For Courbet, as for so many artists, imitation was an integral part of formation. By copying, he became who he was. Particularly important were the Spanish masters Diego Velázquez (1599–1660) and Francisco de Zurbarán (c. 1598–1662) and some classic Dutch painters, especially Frans Hals (c. 1582–1666). As the great German critic Julius Meier-Graefe (1867–1935) remarked, Courbet's art is "unimaginable" without the example of how those earlier painters deployed the color black. A glance at some of Courbet's best known paintings—*The Artist's Studio* (1855), *The Burial at Ornans* (1850), his many paintings of river caves and chasms—instantly shows what Meier-Graefe meant. Courbet tended to paint from dark to light, and blackness for him, as for his mentors, signified the ground, not the absence, of pictorial drama.

Courbet scandalized the taste of his time by his uncouthness—pictorial as well as personal. In part, perhaps, it was a calculated maneuver. Meier-Graefe remarked that Courbet's "subtlety was his brutal boorishness. . . . In Paris this unpolished fanatic was like a bear in a nest of bees." He might have added that although the bear may be stung, he usually gets the honey. Clement Greenberg echoed both Meier-Graefe's praise and his reservation. Courbet, he wrote in 1949, was "a very great artist" whose "great fault was his refusal to be cultivated." He painted very rapidly, using lots of paint, often abandoning the brush for the palette knife in order to sculpt the surface of his pictures. The physical turbulence of Courbet's work offended many critics in his own day, and even his admirers noted that his

work varied widely in quality. One contemporary remarked that "M. Courbet produces pictures in almost the same manner as a tree bears fruit"—meaning organically but also automatically, that is, without thought. Meier-Graefe sounded a similar note when he observed that Courbet produced in "a vegetable fashion, bringing forth good fruits one year and bad the next, without any obvious reason for the variation."

Courbet painted in a wide variety of genres. He did portraits. He made thrilling landscapes and seascapes. He painted nudes, from the prim and proper to the frankly lubricious. (It seems somehow appropriate that the most infamous of the latter, *The Origin of the World* [1866]—a graphic close-up of a woman's pubic area— used to belong to the psychoanalyst Jacques Lacan.) He painted what might be called proletarian genre pictures—*The Stone Breakers* (1850),* for example, a work that in its day was famous—notorious, rather— for its unsentimental portrayal of laborers repairing a road. He made sculpture. He painted hunting scenes, including such famous ones as *The Dying Stag* (1861).

One pleasant thing about Courbet's painting is that, however fraught it might be with visual drama, it is eminently straightforward. I mean, here you have two chaps fixing a road, there a funeral ceremony in a French village, there a nude or a hunting scene. You know where you are. Courbet, in accordance with his efforts to paint realistically, produced art that was *accessible*, generally unproblematic, easily understood.

* This famous picture, formerly in Dresden, was destroyed by Allied bombing toward the end of World War II.

"Presentness" on parade

Or so one might have thought until stumbling on the work of Michael Fried, the J. R. Herbert Boone Professor of Humanities at the Johns Hopkins University and director of the humanities institute at that distinguished university. A bit of background: Professor Fried, the author of several volumes of art history, is a graduate of Princeton University. He was a Rhodes Scholar and is an alumnus of Harvard's prestigious Junior Fellows Program. He began his career in the mid-1960s as a disciple of Clement Greenberg. In 1967, he published "Art and Objecthood," a hugely influential attack on minimalist (what he called "literalist") art and a celebration of some strains of abstract modernist art. That essay, first published in *Artforum*, is a loose, baggy monster, full of quirky formulations, passionate asides, tense engagements with the question of what distinguishes genuinely modernist art from minimalist art. So many of Professor Fried's later preoccupations are broached in "Art and Objecthood"—above all, what he specifies as the "crucial distinction . . . between work that is fundamentally theatrical and work that is not"—that it is worth pausing to consider his argument there.

Exactly what Professor Fried means by "theater" and "theatrical" is not easy to explain. It is something bad, we know that much, because Professor Fried assures us early and often that "theatre is now the negation of art," that "theatre and theatricality are at war today . . . with art as such," and that "art degenerates as it approaches the condition of theatre."

The issue of time or duration is crucial to what

Professor Fried means by "theater." He claims that the art he doesn't like is "preoccupied" with time and the viewer's experience of duration. That is part of what makes it "theatrical." The viewer or "beholder" remains conscious of himself engaged in the act of looking. The persistence of self-consciousness betokens the presence of theater. By contrast, the art that Professor Fried does like (paintings by Kenneth Noland, for example, or sculpture by David Smith) is said to "defeat theatre" by suspending the viewer's experience of time or duration and absorbing his attention utterly: "it is as though one's experience [of this art] *has no* duration"— not, Professor Fried hastens to add, because "one *in fact* experiences . . . [it] in no time at all, but because *at every moment the work itself is wholly manifest. . . .* It is this continuous and entire presentness . . . that one experiences as a kind of *instantaneousness.*"

Yes, well. That sounds pretty good, doesn't it? What do you suppose it means? And more to the point, does it actually illuminate any of the art Professor Fried discusses? You probably know what a typical painting by Kenneth Noland looks like. If not, imagine an archery target, with its contiguous circular bands of color. That comes pretty close. The question is, when you look at such a painting (or at a sculpture by David Smith), do you experience "a continuous and entire presentness," "a kind of *instantaneousness*" (or even "instantaneousness" without italics)? I doubt it.

In fact, I do not believe that "Art and Objecthood" has much of anything to tell us about particular works of art. Nor do I think it sheds much light on its ostensible "big subject": the difference between Minimalism and certain specimens of abstract art *circa* 1967. That

essay became such an influential document not because it illuminated any particular art or offered any real insights into the nature of contemporary artistic practice but because it provided an impressively intellectual story that could *substitute* for the experience of art.

The canny thing about "Art and Objecthood" was the way it applied a certain high-temperature aesthetic rhetoric to art that had hitherto been regarded in notably more prosaic, or at least less ostentatious, terms. Professor Fried doesn't like art that is "theatrical," but then who does? People have been criticizing art that is "theatrical"—i.e., histrionic, not genuine—forever. Nietzsche, for example, famously castigated Wagner for being "an actor" who wanted "effect and nothing but effect," whose devotion to theater "won the crowd" but "corrupted taste." ("What are the *three demands*," Nietzsche asked in *The Case of Wagner*, "for which . . . my love of art has this time opened my mouth? That the theater should not lord it over the arts. That the actor should not seduce those who are authentic. That music should not become an art of lying.") Professor Fried's innovation was to pretend that his use of "theater," "theatricality," etc., marked an exciting advance over the traditional understanding of those terms. It is a subject to which he has devoted many pages, including an entire book: *Absorption and Theatricality: Painting and Beholder in the Age of Diderot* (1980). His use of "theater" and its cognates, full of ominous asides about "the special complicity that the work extorts from the beholder," "the body," etc., is certainly more elusive than the traditional understanding of those terms. But is it any more revelatory? Is it, in fact, anything more than a bit of

verbal stagecraft: ironically, a bit of *theatrical* rhetoric posing as an anti-theatrical broadside?

Similar questions can be asked about Professor Fried's notion of "presentness." The idea that aesthetic experience affords a sense of completeness that seems "outside time" is of course a thoroughly traditional notion. Schiller, to take just one example, observed in *Letters on the Aesthetic Education of Man* (1793) that "the aesthetic alone is whole in itself" and offers an experience in which "we feel ourselves snatched outside time." Professor Fried's innovation was to repackage this hoary idea with the imposing term "presentness." (In later works he speaks instead of "absorption.") The combination of astringent art—Noland's targets, Smith's abstract sculpture—and lofty aesthetic rhetoric was catnip to Professor Fried's audience. How gratifying to believe that a target painting by Kenneth Noland was not just bands of artfully arranged color on canvas but a bearer of "presentness" that "defeats or suspends theater." And when Fried concluded his essay with the assertion that "Presentness is grace," he contributed just the right tincture of quasi-religious verbiage to diffuse an edifying aroma of profundity.

I said above that Professor Fried began his career as a disciple of Clement Greenberg. That is not quite accurate. He at one time *presented* himself as a disciple of Greenberg. That was hardly surprising. These days, Greenberg (1909–1994) is widely disparaged by trendy academics as a practitioner of "formalist," i.e., non-political, criticism. As Rosalind Krauss, another reader-proof former disciple, sneered: "He only thought it respectable to talk about their art." In the

mid-1960s, however, Greenberg was the most influential art critic writing. He was also one of the most articulate champions of the sort of art Professor Fried wished to promote. There was, in 1967, a lot of mileage to be got out of aligning oneself with Clement Greenberg. So it is not surprising that in "Art and Objecthood" Professor Fried quotes Greenberg with approval and suggests that he is extending the sort of analysis of modernist art that Greenberg had pioneered. But the real aim of "Art and Objecthood" was not to open his readers' eyes to certain art works; it was to beguile them with a *theory* about modernist art. Greenberg deliberately employed a spare, no-nonsense prose style in order to keep the focus of his criticism on the art he was evaluating. Professor Fried has always done the opposite. He has employed an increasingly baroque style that threatens to smother the art he writes about. This tendency was already present in early essays like "Art and Objecthood." In his more recent work, art exists as little more than a prop in the drama of Professor Fried's critical fantasy. This is most spectacularly evident in his treatment of Courbet.

Structurally feminine art?

I believe that Professor Fried first turned his attention to Courbet in the mid-1980s. In 1990, he published *Courbet's Realism*, which enlists the painter in Professor Fried's long-running road show about art that he says is "theatrical" versus art that he says is "anti-theatrical." In some ways, *Courbet's Realism* is an amazing performance. Professor Fried tells us that the "central

issue" of the book is "the relationship between painting and beholder in Courbet's art." But that is just a pretext, a rack upon which Professor Fried can hang a bewildering variety of items from the storeroom of contemporary academic theory.

Did you know that Courbet's art was fundamentally an "allegory of its own production"? *A Burial at Ornans* is a huge (ten-by-twenty-one foot) picture of a church burial service replete with open grave, grave digger, and a large cast of clerics and mourners. You might have supposed that the depicted shovel was, well, a *shovel*. But no, according to Professor Fried it "may be likened to the painter's brush." You might have thought that Courbet ended his paintings where he thought they should end. But for Professor Fried, Courbet had a "propensity for calling into question the ontological impermeability of the bottom framing-edge." (What do you suppose that means?) Would you have guessed that Courbet's realist paintings provide "an archetype of the perfect reciprocity between production and consumption that Karl Marx in the 'General Introduction' to the *Grundrisse* posited"? Or that Courbet—yes, Courbet—had latent feminist, indeed, "feminine" tendencies? *Young Women on the Banks of the Seine (Summer)* (1856–7) shows two women in festive dress drowsily reclining on a riverbank. The one closer to the viewer wears a frilly white dress with two bands of orange-brown embroidery on the ample skirt. She lolls languidly, eyes half shut. The other has propped herself up and looks dreamily out, supporting her head on her gloved left hand while her right arm cradles a large bouquet. Professor Fried has this to say about Courbet's summer idyll:

My argument can be summed up by saying that in the *Young Women*, what appears at first to be simply or exclusively a strongly oppositional thematics of sexual difference (the women as objects of masculine sexual possession) gives way to or at the very least coexists with a more embracing metaphorics of gender (a pervasive feminization of the pictorial field through an imagery of flowers), which in turn demands to be interpreted in the light of a specifically pictorial problematic (Courbet's anti-theatrical project).

Although Professor Fried concedes that Courbet was "a representative male of his time" (in other words, "a chauvinist," as he later puts it), he nonetheless argues that "the measures he was forced to take to defeat the theatrical meant that the art he produced is often structurally feminine."

What, you may ask, is "structurally feminine" art? What, for that matter, is a "structurally masculine" art? Do such categories properly belong to art at all? Or is such rhetoric merely an *imposition* of late-twentieth-century ideology? Professor Fried, up-to-date in feminist as in all other branches of theory, has a lot to say about how Courbet's paintings eliminate "the basis of the distinction between seeing and being seen on which the opposition between man as bearer and woman as object of the gaze depends." And his discussion is full of meditations on "the metaphorics of phallicism, menstrual bleeding, pregnancy, and flowers." (The inclusion of flowers, you must admit, is a nice touch: "pansies, that's for thoughts," Ophelia.)

But ask yourself this: what would Courbet have to say if someone told him his painting strove to

"eliminate the distinction" between the sexes? Or that it was concerned with "the metaphorics of phallicism, menstrual bleeding," etc.? The scattering of grain in *The Wheat Sifters* (1853–1854), Professor Fried tells us, "can also be seen as a downpour of menstrual blood—not red but warm-hued and sticky-seeming, flooding outward from the sifter's rose-draped thighs." Unfortunately for this interpretation, Courbet clearly, indeed cleverly, painted grain, not blood. It is one of the triumphs of that painting that he is able to make his pigment seem so light and airy; *pace* Professor Fried, it impresses the viewer not as something that floods outward from the sifter's thighs but that floats down from the sifting pan she holds out before her. Look and see.

Here as everywhere Professor Fried operates with a formidable *criticus apparatus*, a huge and plodding academic machinery. We are impressed with his bibliography but wonder what happened to the art. If one didn't know better, one might think he was attempting a comic impersonation of some particularly unfortunate pedant. Almost a quarter of the book is given over to notes: long, arcane notes, notes that wander and digress, notes that include lengthy passages from Hegel and Marx and Walter Benjamin in German, Jacques Lacan in French—notes, in short, that in many cases have absolutely nothing to do with the painting of Gustave Courbet. Occasionally, Professor Fried comes close to admitting as much. "The claims I advance about Courbet's art are so extreme—what I see as taking place in his paintings is pictorially and ontologically so remarkable—that it seems altogether unlikely that any nineteenth-century critic, that indeed

Courbet himself, could have understood the meaning of his enterprise developed in this book." Indeed.

The triumph of the imaginary

It is amusing to contemplate what Courbet would have thought of Professor Fried's interpretation of his work. It would have been especially nice to have had his reaction to Professor Fried's interpretation of *The Quarry*, a hunting scene that Courbet painted in 1856, not long after finishing *The Artist's Studio*, one of his great masterpieces.

Courbet himself was in a transitional phase. Behind him were some of his most ambitious genre pictures and portraits—*The Stone Breakers, The Burial at Ornans, The Wounded Man* (1844–1854), *The Artist's Studio, The Wheat Sifters*. Ahead were many more nudes and portraits and above all a tremendous body of powerful landscapes and seascapes. *The Quarry* bespeaks that moment of meditative reassessment: the task at hand successfully completed, future tasks to come. It was at this period, as Courbet's biographer Jack Lindsay notes, that he "developed a power to define varying atmospheric effects, linked with the kind of country that produced them. In carrying further the attempts to translate specific light-qualities, he formed the bridge between Corot and the men of Barbizon, and Pissarro and Monet."

In the context of Courbet's other hunting scenes, *The Quarry* (which now hangs in Boston's Museum of Fine Arts) occupies a middling rank. It is, as Meier-Graefe noted, a picture possessing "great charm of modelling."

The juxtaposition of the figures—a delicate play of lights and darks—communicates a rippling harmony of color and mood. Meier-Graefe found something "hard and dull" about the overall effect, though I suspect most people will be struck chiefly by the painting's atmosphere of recuperative though vivacious calm.

It seems pretty straightforward, doesn't it? The title that the picture bore when it was exhibited in the Salon in 1857 gives an admirable summary: *La Curée, chasse au chevreuil dans les forêts du Grand Jura*, "The Quarry: Hunting a roe deer in the forest of the Grand Jura." What more can one add?

Take a look at the plate illustrating the picture. Here we have an ordinary hunting scene that depicts a moment of rest after a successful hunt. In the left foreground, we see the vanquished deer—the "quarry" of the title—hanging from a branch, its head lolling sideways on the ground. To the right, receding deeply into a shadow, the tired hunter—generally acknowledged to be a self-portrait—leans back dreamily against a tree. Further to the right, the *piqueur*, the master of the hounds, sits in a brilliant slip of light blowing a hunting horn. In the right foreground, two dogs, also brightly illuminated, frisk playfully. The picture was composed in stages on separate pieces of canvas. The hunter and the roe deer occupy one segment, apparently the first painted. The closely modulated browns and whites—moving from the shadow-enveloped hunter out to the lucid, scrutinizing clarity of the deer—articulate one movement, the strophe, of the painting's emotional substance. The antistrophe is marked by the second major segment, which includes the more allegro figures of the *piqueur* and the frolicking hounds. Courbet

finished the picture with strips of canvas on the extreme left and the top of the picture.

It is well to supply this simple description at the outset, for as Professor Fried proceeds with his interpretation one's grasp of the particulars of Courbet's painting is likely to become shaky. Among much else, Professor Fried's interpretation indulges heavily in a favorite tactic of contemporary academic criticism: namely, the principle that holds that whatever a work (poem, painting, novel, essay, etc.) is ostensibly about, at bottom it is self-referential, being primarily a symbol of the activity of painting or writing. The overt subject of the work may mislead one into supposing that it is really about something else, something quite tangible in one's physical or emotional experience—a hunting scene, for example. But an adroit practitioner of the new academic criticism easily overcomes such "extrinsic" objections.

One powerful aid in this task is the word "symbol" and its fashionable variants: "metaphor," "metonymy," "synecdoche," "trope," etc. Like the philosopher's stone, recondite use of these terms can transform the base material of reality into the gold of "intertextuality." Professor Fried provides us with many wonderful examples of the procedure. We do not have to read far in his interpretation of *The Quarry* before we are told that the *piqueur* is really

another of Courbet's characteristically displaced and metaphorical representations of the activity, the mental and physical *effort*, of painting. Thus the young man's strange, half-seated pose (with nothing beneath him but his folded jacket!) may be taken as evoking the ac-

tual posture of the painter-beholder seated before the canvas. The hunting horn, held in his left hand, combines aspects of a paintbrush (I'm thinking of the horn's narrow, tubular neck) and a palette (its rounded shape . . .) while strictly resembling neither, and of course a horn being blown is also a traditional image of the fame Courbet forever aspired to win by his art.

One only wonders what Professor Fried has against the dogs: why aren't they, too, figurations of "the painter-beholder"? Isn't their playfulness there in the painting's foreground a symbol of the playful dialogue of the creative mind at work—doubled to represent the simultaneous interplay of the productive and critical faculties, tokens of the artist's awareness of his intractable animality, etc., etc. It's easy to spin out this stuff once you get the hang of it. But let's allow Professor Fried to continue.

It follows [does it?] that the figure of the hunter, whom I have also called the hunter-painter, may be read as representing if not a certain beholder at any rate a certain theoretical entity: not, I think, the beholder *tout court*, but rather the beholder-"in"-the-painter-beholder—the ostensibly passive half of the painter-beholder's compounded identity—which in turn means that the *piqueur* represents the other, manifestly active half of that identity, and that the *Quarry* as a whole pictures the splitting of the painter-beholder into separate components that in chapter four I claimed

The sentence is only about half over now, but why continue? It doesn't get any better.

Professor Fried is far too busy speculating to register even the basic topography of the pictures he discusses. He suggests that the *piqueur* is in a "strange, half-seated pose . . . with nothing beneath him but his folded jacket." But isn't it clear that he has put his jacket on a bulging part of the tree upon which he sits? Professor Fried tells us that the figures of the two men in *The Stone Breakers* and the two women in *The Wheat Sifters* trace or "delineate" the letters "C" and "G," the painter's initials, and that this was "still another mode of self-representation." The problem is that those figures do not resemble the letters "C" and "G" any more than they resemble the Brooklyn Bridge —which is to say, not at all.

Operating on the principle that if something is not shown, it is more present than if it is, Professor Fried has no trouble populating the canvas with all manner of objects and significances that Courbet somehow forgot to include. Is there no gun depicted in the painting? No problem: "In place of the missing musket there is the *piqueur*'s hunting horn, previously described as symbolizing the painter's tools (and therefore linking those tools with the absent weapons)." *Therefore?* "Therefore" approximately in the sense of "Abracadabra" or "Open Sesame."

But what about sex? It is the rare example of trendy academic criticism these days that does not include a large dash of talk about sex, the more outlandish the better. But where in this forest scene could one conjure sex? A tired hunter, self-absorbed *piqueur*, two dogs, and a dead deer may not seem much to work with. But Professor Fried does not disappoint. "I for one," he confides, "am struck by the implied violence of the ex-

posure to the hunter's viewpoint of the dead roe deer's underside, specifically including its genitals."

ONE HAS TO ADMIRE Professor Fried's brass—and his well-developed sense of just how far he can intrude upon the reader's credulity without making concessions to common sense. "The last observation may seem excessive," he allows.

> For one thing, I am attaching considerable significance to a "side" of the roe deer we cannot see as well as to a bodily organ that isn't actually depicted. For another, the hunter isn't looking at the roe deer but faces in a different direction. But I would counter that we are led to imagine the roe deer's genitals or at any rate to be aware of their existence by the exposure to our view of the roe deer's anus, a metonymy for the rest. . . . I would further suggest that, precisely because the roe deer's anus stands for so much we cannot see—not simply the roe deer's genitals and wounded underside but an entire virtual face of the painting—such an effect of equivalence or translatability may be taken as indicating that the first, imaginary point of view is more important, and in the end more "real," than the second.

The imaginary point of view is more important and in the end more real than the point of view discerned with one's eyes: this sums up Professor Fried's method. But wait, there is more. In a long footnote to this passage, he tells us that

> My suggestion that the *Quarry* calls attention to the roe deer's undepicted genitals and to their exposure to

the hunter or at least to his point of view invites further discussion in terms of the Freudian problem of castration. Now what chiefly characterizes the painting's treatment of these motifs (if I may so describe them) is the absence of any signs of special or excessive affect and in particular of anxiety, which may seem to indicate that for the painter-beholder the implied threat to the roe deer's genitals was simply that, an objective menace, not the expression of a primal insecurity. On the other hand, the absence of affect ought perhaps to be seen as a further expression of the splitting of the painter-beholder into passive hunter and active *piqueur*: that is, it would be a further index of the hunter-painter's manifest passivity, which itself might be described as a sort of castration.

Consider: the roe deer's genitals are undepicted, therefore the painting "invites" discussion in terms of the Freudian notion of castration. The hunter isn't looking at the deer (but how could he? His eyes are all but closed with fatigue); no matter, the deer's genitals are exposed "at least to his point of view" (i.e., if he only turned his head and opened his eyes, he would see them). Despite this alleged threat of castration, the hunter displays no special signs of affect or emotion, quite the opposite, in fact—never mind: being passive may itself be described as "a sort of castration" (on which account I suppose that a painting of a man asleep or unconscious or dead would provide an even more dramatic index of preoccupation with castration). Poor Courbet!

Even to raise objections risks complicity with Professor Fried's undertaking, imputing to it a measure of

credibility it can never have. What he offers is not an interpretation but a violation of Courbet. The most effective response is not argument but repudiation—or perhaps, as I suggested in the Introduction, simple ridicule. The idea that *The Quarry* has *anything* to do with castration—indeed, that it has anything to do with sexual violence period—is simply ludicrous. Patient objections to the ludicrous risk becoming ludicrous themselves. If any aspect of Freudian hocus-pocus has a bearing on the matter, it is not Freud's conjectures about castration anxiety or "displacement" but his ideas about free association: here at any rate we may have an analogue to Professor Fried's own critical procedure.

Professor Fried's speculations about the hidden sexual current in Courbet's painting are perhaps the most outrageously absurd aspect of his interpretation of *The Quarry*. But in many ways even more absurd— because it touches directly on the core of Courbet's painting—is the end to which Professor Fried's complex hermeneutical apparatus tends. In Professor Fried's hands, Courbet emerges as an artist whose work is fraught with all manner of "metaphysical meaning" and aspiration. But the truth is that in the repertoire of Courbet's beliefs, there is nothing that can even remotely be described as a "metaphysics." Professor Fried tells us that paintings like *The Quarry* show how in Courbet's work "an absorptive thematics comprising a range of states from (relatively) active to (relatively) passive is grounded in the painter-beholder's vigorous yet also automatistic [*sic*] engagement in a sustained act of pictorial representation that the painting itself . . . can be shown to represent." But that is just hooey (and bad English to boot). Few painters can

have been more overtly *anti*-metaphysical than Gustave
Courbet. In part, that is what the usual description of
him as a "Realist" intends. Courbet himself put the
matter with admirable clarity in 1861 in a letter to his
students. The emphasis is his.

> I also believe that painting is an essentially CONCRETE
> art and can only consist of the representation of REAL
> AND EXISTING objects. It is a completely physical lan-
> guage that has as words all visible objects, and an
> ABSTRACT object, invisible and non-existent, is not part
> of painting's domain. Imagination in art consists in
> knowing how to find the most complete expression of
> an existing object, but never in imagining or in creating
> the object itself.

So much for Professor Fried's contention that the "im-
aginary point of view is more important, and in the
end more 'real,'" than what one sees with one's eyes.

Professor Fried provides a good example of what
happens when an intelligent fellow becomes addicted
to "theory." At first you hardly notice the ill-effects.
There's the usual academic fondness for jargon and
"big ideas," but that's a common occupational hazard
and by itself is not necessarily a cause for concern.
Gradually, however, what began as a certain woolliness
and verbal ostentation becomes an extravagant flight
from reality. You look at an ordinary hunting scene
and start hallucinating about "undepicted genitals,"
the "Freudian problem of castration," and unpleasant
aspects of animal carcasses that you can't even see ex-
cept from "an imaginary point of view." Doubtless the
patient starts out thinking, "I can take it or let it

alone." Yet how often what begins as a recreational use of theory becomes a habit! (Consider what Professor Fried does to those poor wheat sifters.) And how often the habit becomes a necessity, the necessity an importunate addiction. Before long, alas, another mind is a slave to theory, "sicklied o'er with the pale cast of thought," useless to itself, a burden to others. I've often speculated that William Hogarth, were he alive today, might devote a moral allegory—*The Prof's Progress?*—to the subject.

At the end of *Hamlet*, Fortinbras enters the castle at Elsinore and discovers the stage littered with corpses. "This quarry cries on havoc," he says, appalled at the carnage. "Havoc, *n.*, widespread destruction, devastation." When Professor Fried sets his sights on Courbet, *The Quarry*, too, cries on havoc. "The sight," as another character in *Hamlet* comments, "is dismal."

Chapter 2
Inventing Mark Rothko

HAMLET: *Do you see nothing there?*
QUEEN: *Nothing at all; yet all that is I see.*

Was Rothko a realist?

WHAT MICHAEL FRIED did to Courbet was undeniably something special. Professor Fried has plenty of competitors—we'll meet several of them in the pages that follow—but let's give credit where credit is due. For all-round hermeneutical perversity and willful misinterpretation, Michael Fried surely deserves some sort of commendation. Particularly impressive is the *seamlessness* of his performance. Page after page, footnote after footnote: it's a vacuum-packed, hermetically sealed environment. No hint of a shadow of an adumbration of common sense enters anywhere. Professor Fried has successfully blocked off all routes of ingress. So long as you can suppress a giggle it is difficult not to be a bit awestruck by the unremitting *owlishness* of his act. Is it really "tempting to compare the feminization of the phallus/paintbrush in the *Young Women on the*

Banks of the Seine with the implied castration of the dead roe deer and indeed of the passive hunter in the *Quarry*"? Of course not. For anything less tempting you would have to turn to Professor Fried's fantasies about menstruation and *The Wheat Sifters*. But how . . . *impressive* that someone—an adult, moreover, and holder of a named chair at a distinguished university—how breathtaking that someone like that should write and apparently believe these things. As I say, it is pretty special.

But of course there is a sense in which Courbet makes it easy. I mean, his pictures are plainly about things out there in the real world—hunting, funerals, an artist's studio, laborers, etc.—and so a clever academic has plenty of fodder for hermeneutical ingenuity. In a world where a hunting horn is a paintbrush, which is a phallus, which is a metonymic flag for the artist's desire for fame, fear of castration, longing for scrambled eggs, or whatever, *anything* is possible. Not every artist makes it so easy. Courbet gives you a stage set with people doing things. What about artists specializing in abstraction? If a canvas is filled with non-representational colored shapes, what then?

Well, interpretation would in one sense be less restrained. Presented with the artistic equivalent of a Rorschach test, the viewer is almost invited to fantasize. But by the same token interpretation has fewer definite catalysts for fancy: a colored shape, be it ever so artfully applied, offers fewer aids to interpretive flight than the representation of some recognized object.

Or so one might have thought. The case of Mark Rothko illustrates how far a determined critic can go on the basis of two or three rectangular bars of color.

On the occasion of a big traveling retrospective of Rothko's work in 1998, a press release boasted that "Rothko's achievement has had a decisive impact on the course of twentieth-century art and has given rise to a wealth of critical interpretation." The first bit is at least arguable; the second is indisputable.

The artist we know as Mark Rothko (1903–1970) was born Marcus Rothkowitz in Dvinsk, Russia, the youngest of four children. His father came to the United States in 1910, settling in Portland, Oregon, where his brother had preceded him. In 1913, Marcus followed with his mother and sister.

Rothko—he changed his name in 1940—came to art relatively late. He spent a couple of years at Yale—he had initially contemplated a career in engineering or the law—but left in 1923 without having taken a degree. He moved to New York, where he worked in the garment district and as a bookkeeper. In 1924, he began taking art classes and over the next few years studied with a number of influential painters, including George Bridgman, Arshile Gorky, and Max Weber. Probably the biggest influences on his art were Milton Avery (1893–1965), whom Rothko met in the late 1920s, and Pierre Bonnard (1867–1947), whose paintings he would have seen in New York at the end of 1946. In their different ways, both artists were masters of the sort of color modulation that Rothko would distill, simplify, and exploit in a purely non-representational mode.

Rothko's early painting was realistic and forgettable. By the early 1940s, under the influence of Joan Miró (1893–1983) and Giorgio de Chirico (1888–1978), he was producing a species of heavy "symbolic" abstractions that were intermittently surrealistic and forget-

table. Rothko didn't really come into his own—he didn't begin producing the work we instantly recognize as *his*—until the late 1940s. From 1949 through the 1950s, he produced some of the most ineffably fetching abstract pictures ever painted. Rothko made some good paintings in his last years—he died by his own hand in 1970—but from about 1960 his work was more and more likely to have a certain rote quality, to lack freshness and conviction.

You are certain to have an image of what are often called Rothko's "classic paintings." The best are largish vertical rectangles five or six feet tall. A typical Rothko features a variegated yet monochromatic ground of color upon which seem to float or hover two misty rectangles, one above the other, almost but not quite touching. Together, they nearly fill the picture plane. Often, one of the rectangles harmonizes closely in color value with the ground while the other contrasts more or less sharply. There are several variations of this pattern. Some of Rothko's pictures include more than two bands or lozenges of color, others feature vertical patches of color. In a few pictures, a relatively narrow, somewhat uneven strip of color complements one or more rectangles. Hard edges are a rarity in Rothko's mature work. His areas of color seem bled or washed upon the canvas, not drawn. Adjectives like "gauzy," "translucent," and "filmy" abound in descriptions of this work.

Not everyone likes Rothko's painting. On the occasion of a retrospective of his work at the Museum of Modern Art in 1961, a critic for *The New York Herald Tribune* described his paintings as "first-class walls against which to hang other pictures." (One recalls

Henry James's reaction to a puppet show: a remarkable economy of means, he said, but also a remarkable economy of effect.)

For many viewers, however, Rothko's best pictures exercise a powerful but hard-to-define charm. I believe that the seductiveness of Rothko's pictures inheres chiefly in their cunning exploitation of shape and color. Of course, that is not saying very much, for the seductiveness of *any* painting inheres largely in its manipulation of shape and color. That, after all, is what painting *is*.

But Rothko's work is distinctive in its combination of abstractness, simplicity, and sensuous color. Rothko had an unusual knack for balancing two or three colored shapes on an essentially monochromatic field to produce a sumptuous and mesmerizing effect. This is one reason that the question of *temperature* is often paramount in appreciating Rothko's pictures. His skill in deploying color was bound up with the emotional valence—from warm to chilly—associated with certain hues and combinations of hues. Curiously, the power of Rothko's work is cumulative: several paintings together in a room create an effect that is more than the sum of the individual canvases. By the same token, however, Rothko is an artist one can easily overdo. His work is quiet, moody, rich: to be effective, it demands a quiet receptivity that, if prolonged, if indulged too often or too largely, can be cloying.

To sum up: the first two things you notice about Rothko's mature paintings are 1) their adroit if distilled manipulation of color and 2) their utter abstractness: a reddish-brown rectangular field, say, upon which rests an orange rectangle and, above it, a green rectangle of

the same size. *C'est tout*. It is ironical, then, that Rothko himself was adament that 1) he was not a colorist and 2) he was not an abstract painter. "I'm not interested in color," he repeated again and again; "I'm not a colorist." Similarly, he often insisted that he was a realist. In 1952, for example, he declared in an interview that "Abstract art never interested me; I always painted realistically. My present paintings are realistic." To another puzzled interviewer a few years later Rothko snapped: "You might as well get one thing straight, I'm *not* an abstractionist."

I have no idea what Rothko meant by denying that he was interested in color—if indeed he meant more than to issue a provocation. But there *is* one sense in which I can understand his repudiation of the adjective "abstract." In *The American Heritage Dictionary*, the first definition of "abstract" is "Considered apart from concrete existence: *an abstract concept.*" The second is "Not applied or practical: theoretical." The third is "not easily understood; abstruse." The fourth is "Thought of or stated without reference to a specific instance: *abstract words like 'truth' and 'justice.'*" Rothko's "classic pictures" are not really abstract in any of these senses. On the contrary, they are closer to the opposite of abstract in these senses: they are immediate, not abstruse; palpable, not removed from "concrete existence"; and so on.

Nevertheless, there is something Pickwickian—not to say downright perverse—about denying that Rothko is an abstract artist (and even more about claiming that he was a "realist"). And this in fact is recognized by the dictionary, whose next definition of "abstract" specifies a "genre of painting or sculpture whose intel-

lectual and affective content depends solely on intrinsic form." Consider the illustration of Rothko's *Untitled, 1953*: if someone were to ask, "What is it about?," most of us would give a very different sort of answer from that we would give if asked what Courbet's *The Quarry* was about. In the latter case, we would say, "It's about a moment in the forest after a successful hunt. It's a hunting scene." In the case of the Rothko, there is no such publicly available correlative. Perhaps we would say that it is "about" the mood or emotion instigated by Rothko's arrangement of form and color. But that sense of "about" is almost as unsatisfactory as saying that the painting is "about" itself.

Rothko and "the human drama"

Rothko was deeply impressed by his reading of the Greek tragedians, Shakespeare, and Nietzsche. He saw that their works dealt with an enormous range of human incident and moral passion. He wanted his own work to exhibit that kind of existential density. He denied that he was an abstractionist and embraced the term "realist" because he believed (or wanted to believe) that his painting embodied the philosophical and moral gravitas of his favorite authors. His canvases, too, he believed (or at any rate *said*) documented "the human drama" in all its magnificence, loftiness, and tragedy. When it comes to art, Rothko intoned, "only that subject is valid which is tragic": "all art deals with intimations of mortality."

Exactly how his pictures deal with the "tragic" or with "intimations of mortality" is not an easy question

to answer. The critic Hilton Kramer bore witness to that difficulty in his essay "Was Rothko an Abstract Painter?" When we find ourselves in the presence of a mature picture by Rothko, Kramer asked,

> what is there in what we see in the abstract forms of [the] painting that can be taken to refer to, or to embody, the metaphysical "subject" which the artist himself claimed for the work? Is that claim to be taken literally? If not, then in what sense is it to be taken? If we cannot actually *see* the artist's metaphysical "subject" in the physical object he has created for the avowed purpose of giving it expression, how can that subject be said to be present in the work?

How indeed. And yet, as Kramer notes, not only did Rothko deny that he was an abstractionist but also he "made the issue of denial a crucial test for his admirers, and as a result they tended, by and large, to support his claim without significantly clarifying it."

Although Rothko abetted those critics who attempted to populate his works with the kind of deep subject matter after which he hankered, he occasionally had reason to rue his support. A case in point was the catalogue essay that Peter Selz contributed to the Museum of Modern Art's Rothko retrospective in 1961. It is not clear to me whether Rothko found fault with Selz's essay right off the bat. It is more likely that his disapproval followed the hilarious send-up of Selz's essay that the artist and critic Sidney Geist published in his short-lived semi-samizdat art publication *Scrap*. Geist presented a photocopy of Selz's essay in one column with his own running commentary—a series of

footnotes keyed to Selz's essay—alongside. It was a classic performance.

Selz begins by claiming that the painters of the New York School "set out to paint their own environment," remarking that "the vast plateaus of the Northwest, the vaster bottom-lands of Texas constitute only a small part of the artistic experience of the painters, whose culture is based chiefly on European art." "In his New York studio," Selz continues (the footnotes to the following are Geist's: I can't improve on them),

Mark Rothko has built a new habitat* of extraordinary emotional dimensions. His paintings can be likened to annunciations.† Rothko returned from a trip to Italy with great admiration for Fra Angelico's frescoes in the monastery of Saint Mark's. But no angels and madonnas, no gods, no devils furnish a common property to be invoked‡ in Rothko's paintings. There is no public myth to express the modern artist's message for him.§ The

* Has Rothko built a *habitat*, or has his studio a special character because of the presence of his paintings?

† A Non Sequitur (NS). In modern English there are no "annunciations," there is only *the* annunciation (usually capitalized)— of the angel Gabriel to Mary that she would bear the Christ child. Yes, we're on our way to church.

‡ What can this phrase possibly mean?

§ Has there ever been a public myth that expressed the artist's message for him? Note that in this sentence we have left Rothko, and are dealing with the "modern artist." The next sentence, then, would have to mean that *all* paintings by modern artists are "proclamations" and that their size *always* announces their eminence—and that's a bit much. Proclamations—of what? This is the Incomplete Forward Pass (IFP). By now we have gone from "environment" to "bottom-lands" to "habitat" to "myth" to "message" to "proclamation" [Verbal Slide] (VS).

painting itself is the proclamation; it is an autonomous object and its very size announces its eminence.

Sidney Geist had sly and amusing things to say about nearly every sentence of Selz's essay. But for the most part that essay is an exercise in self-parody, hilarious even without the benefit of Geist's commentary.

> Eventually as other images occur to the viewer the metaphor of the creation of some universe becomes paramount. And increasingly—in the mind of this writer—these "shivering bars of light" assume a function similar to that loaded area between God's and Adam's fingers on the Sistine ceiling. But Rothko's creation can no longer be depicted in terms of human allegory. His separated color areas also create a spark, but now it takes place in some sort of revolving atmospheric universe rather than between Michelangelo's man and his God. Rothko has given us the first, not the sixth, day of creation.

"It was," as Geist comments regarding Selz's "creation of some universe" gambit, "bound to be said."

Well, Rothko knew as well as the next chap when he was being made fun of. Whatever he may have thought of Selz's embroidery to begin with, Geist's commentary helped make Rothko conceive an intense dislike for it. He went so far as to insist that the Museum of Modern Art replace the text of the catalogue when the exhibition traveled to Europe. He did not, however, really learn his lesson, for he continued to insist that his pictures were "realist" paintings that dealt with "the human drama" in all its tragic complexity.

The structure of a pietà?

Nor, as it happens, did the critics and art historians who came after Peter Selz learn much from the Geist treatment. Consider, for example, *Mark Rothko: Subjects in Abstraction* (1989) by Anna Chave, Professor of Contemporary Art and Theory, Twentieth-Century European and American Art at the City University of New York Graduate School. Professor Chave's book is based on her doctoral dissertation (at Yale), and it is an eminently learned production. Professor Chave knows a lot about Mark Rothko, the New York School, and a thousand other things that may or may not illuminate Rothko's work but that sound impressive in a dissertation for Yale.

Having benefitted from a couple decades more of lit-crit-theory than did Peter Selz, Professor Chave is considerably more polysyllabic and evasive in her determinations of Rothko's alleged subjects. She is also far more politically correct. After all, the philosophical themes that Rothko claimed to find in his paintings were precisely the sort of old-fashioned humanist themes that white, male academics used to champion: themes out of Greek tragedy, Shakespeare, etc. We can't have that, of course. So Professor Chave early on lets us know that *she* knows perfectly well that

> the notion that there are universal human qualities and values has been questioned . . . on the grounds that that purportedly universal humanist ethos involves, more specifically and insidiously, the projection or imposition by the dominant race, culture, and gender (read: white Western men) of its own codes of values

(which are honored, most often, in the breach) as the universal norm.

For her part, although she is going to populate Rothko's canvases with all manner of humanist content, she wouldn't dream of venturing "claims for any transhistorical essences." No essences here, you see, just us thoroughly disabused academics.

Similarly, instead of coming right out and saying that Rothko's "paintings can be likened to annunciations" as Peter Selz did, Professor Chave will tell us that Rothko's paintings "can be shown to implement traces of certain elemental and symbolically charged pictorial conventions." Only after stunning you with some such stuff does she bring up the possibility that Rothko's canvases "parallel" or "bear a relation to" a religious or metaphysical subject. She is full of nice, three-dollar words. "Icon," for example—in a "semiological context," Profesor Chave says, it is "germane" to Rothko's paintings—or "palimpsest." Etymologically, "palimpsest" means "scraped again." Back in the good old days, when writing materials were expensive and you really had to work to write something down, people would often erase an unneeded document and write over it; sometimes, years later, the imperfectly erased original could be deciphered underneath the new writing. Professor Chave wants us to consider Rothko's paintings as palimpsests of a sort. "My purpose is to demonstrate how multiple meanings, a palimpsest of meanings, inhere in Rothko's pictures."

That sounds terrific. I, too, like the word "palimpsest." But what's underneath the paint in Rothko's paintings? Nada. Nichts. Rien. Or to speak plainly:

nothing, just blank canvas. "Up to a point" Professor Chave says, "Rothko's art may fruitfully be analyzed as involving a language or sign system." ("Up to a point" as in "Up to a point, Lord Copper.")* Of course there is no telling whether Rothko, despite wanting to be known for dealing with "the human drama," would have approved of Professor Chave's "icons," "palimpsests," "traces," and "decodings." So she early on issues a blanket dismissal of Rothko's opinions: "whether Rothko would have ratified the readings set forth here or recognized his conscious intentions in them is not the crucial issue." In other words, enough about Rothko: let's get back to me and my interpretations.

No such presentation would be complete without some contribution from Hegel, and so Professor Chave periodically treats readers to paragraphs like this, with its long, undigested quotation from Hegel's *Phenomenology of Spirit*:

A glancing reference to Hegel may prove useful . . . for casting light [*light*? When did Hegel ever cast *light*?] on the ramifications of Rothko's conceit [about the inner self]. In place of Cartesian epistemology with its radical separation of subject and object, Fichte, Hegel, and German idealism generally offer a mapping of the in-

* I allude of course to Evelyn Waugh's novel *Scoop* (1937):

Mr. Salter's side of the conversation was limited to expressions of assent. When Lord Copper was right he said, "Definitely, Lord Copper"; when he was wrong, "Up to a point."
 "Let me see, what's the name of the place I mean? Capital of Japan. Yokohama, isn't it?"
 "Up to a point, Lord Copper."

tricate interrelation of these two terms. Hegel argued that the object "only has significance in relation, only through the ego and its reference to the ego"; that is, [*that is?* As if what follows explains what came before] "the trained and cultivated self-consciousness, which has traversed the region of spirit in self-alienation, has, by giving up itself, produced the thing as its self; it retains itself, therefore, still in the thing, and knows the thing to have no independence, in other words knows that the thing has essentially and solely a relative existence." It follows [sure it does] that "the reality, both universal as well as particular, which observation formerly found outside the individual, is here the actual reality of the individual, his connate body."

In his critique of Hegel, Adorno

I'm sorry: I know I promised to be careful of my readers' stomachs.

AT TIMES, Professor Chave's procedure reminds one of a comment made somewhere by the philosopher J. L. Austin: "there's the part where he says it, and the part where he takes it back." Perhaps remembering the fate of Peter Selz, she magnanimously admits that to say that a late Rothko painting actually represented a pietà or an entombment and resurrection "would be blatant distortion." But then she conjures up Bellini's *Pietà* and proceeds to tell us that

> Those images of Rothko's that parallel the pictorial structure of a pietà, such as *White Band (Number 27)* (1954), and *Number 20* (1950) might be said at the same time to parallel the structure of a conventional

mother and child image. Further, and by the same logic, such tripartite pictures as an untitled yellow and black painting of 1953, which bear a relation to the pictorial structure of an entombment, also bear a relation to certain conventional adoration or nativity images.

Well, anything "might be said." *White Band (Number 27)* is a blue rectangle, eighty-one by eighty-six inches; in the center of the rectangle there floats a narrow gray-white band; above it sits a wider blue-gray band, below a band of charcoal-gray. You might say that it parallels "the pictorial structure of a pietà," but then you *might say* that it reminds you of the state of Colorado, Nelson's semaphored message at the Battle of Trafalgar, or Euclid's proof of the Pythagorean Theorem. As for that untitled painting from 1953, take a look at the illustration following page 84. Professor Chave says that it "bear[s] a relation" to the "pictorial structure of an entombment" and "certain conventional adoration or nativity images." Does it? Does it?

What I see when I look at that picture is a tall, relatively narrow rectangle. The ground of the painting is a sort of brownish white. The top two-thirds of the canvas are nearly filled by a yellow rectangle. Underneath that are flecks of white and then an uneven fairly narrow orange stripe. Underneath the orange is a thick block of black extending to the painting's edges, followed at the bottom by a bar of mottled orange with a yellowish center. There's nothing that "bears a relation to," "parallels," is a "trace" or "icon" or "palimpsest" of a pietà, an entombment, a nativity scene, or even your Aunt Joan. Nor is there any "message" that needs

to be "decoded." Rothko's picture is just that: a picture. It is not a "text" to be read or a puzzle that needs to be deciphered or unravelled. It is a painting to be looked at. It is not, in my view, one of Rothko's strongest works. But even if it were his very best, the little dramas that critics like Anna Chave have invented to "explain" or enhance Rothko's paintings would be absurd fabrications.

Rothko's paintings have always been enormously popular because they offer unadulterated aesthetic pleasure. A sensitive arrangement of simple colored forms can be beautiful. The apprehension of beauty affords pleasure, sometimes an intense pleasure, but a pleasure that is without motive, alibi, or ulterior interest—a pleasure, that is to say, which is complete in itself. The fact that such pleasures also belong to the activities of philosophical and religious contemplation has led many thinkers to draw an analogy between aesthetic and religious experience. How seriously we should take that analogy has been a matter of contention for millennia. But it is one reason that art, even—or rather especially—the purest, most wholly aesthetic art, has attracted a sort of libretto of philosophical or quasi-theological justification. Think of Mondrian's neo-Platonism, Kandinsky's theosophy, Malevich's geometrical mysticism.

There are, I believe, two ways to interpret this hankering after significance. One is to say that the pleasures afforded by purely aesthetic experience are essentially thirsty pleasures, which by their very nature crave satisfaction in another, less worldly realm. The other is to say that aesthetic pleasure fails to satisfy when 1) it is regarded as a simulacrum or counterfeit

of other sorts of satisfaction (religious, metaphysical, political) or 2) when it is deployed in a less than consummate manner. In a famous essay from 1955, Clement Greenberg spoke enthusiastically about Rothko's "incandescent color" and "bold and simple sensuousness." At the same time, though, Greenberg noted that Rothko's art "asserts decorative elements and ideas in a pictorial context." The "crucial issue," he thought, was determining "where the pictorial stops and decoration begins." Of course, "decorative" and "decoration" are fighting words these days, diminishing words. They can hardly be used without the prefatory adverb "merely."

Mark Rothko's paintings are assuredly decorative. That is one important reason—not the only reason—that they are so popular. Whether they are *"merely* decorative" is a question I prefer to leave unanswered. But the great lesson that interpreters like Peter Selz and Anna Chave have to teach us is this: that in seeking deep significance in abstract art, generally the first thing to be sacrificed is the art. The adjective remains, but abstract significance seems hardly worth the effort.

Chapter 3
Fantasizing Sargent

These are but wild and whirling words.
—Horatio, *Hamlet* i:v

Inflections, nuance, possibility

JOHN SINGER SARGENT (1856–1925) was only twenty-six when he painted *The Daughters of Edward Darley Boit*. It was the fall of 1882. Having just returned to Paris from Venice in October, the Florence-born American expatriate was already up to his neck in commissions. A life-long pattern was establishing itself. "For him," Sargent's biographer Stanley Olson remarked, "life was not a transit up and down the scale of emotions; it was employment. When he was content he worked *very* hard; when he was less content he just worked hard."

In this, Sargent departed markedly from his family. The second of six children (only three of whom lived to their majority), Sargent was as ambitious as he was diligent. His family, by contrast, subsisted in a bubble of feckless hypochondria, especially his mother's, drift-

ing from Florence to Rome to Paris to Nice, living modestly on their small income, doing nothing. His parents, Olson noted,

> had no friends, few acquaintances, no occupations, in fact nothing apart from themselves and their children to monopolize them. Time weighed heavily upon them, and they awarded themselves every justification to plunge into an unnatural preoccupation with health. John Sargent's extreme youth began as it would continue for nearly twenty years, in a household that quivered on the brink of gloom. Everyone around him possessed a chilling aura of impending doom, of either waiting to be ill or struggling to recover.

Sargent broke this mold, but continued to bear traces of the confinement. He was shy, musical, mannerly in a fastidious *noli me tangere* way. He never married, indulged in no amours. Well travelled and clever at languages, Sargent slid easily into the glittering world of his patrons: an ornament to those he was called upon to provide ornaments for. Unmenaced, as Olson put it, "by introspection or the urge for confession," Sargent was the perfect addition to tony drawing rooms in Paris, London, Boston, Newport, and New York: he was clever, presentable, undemanding. And he was super-competent. Sargent early on mastered the art of subtle flattery. He did not make his sitters more handsome or more beautiful than they were, merely more sumptuous and alluring. With only a few exceptions—his late portrait of Henry James (1913), for example, or his early picture for Edward Boit—Sargent's art, like his life, was devoted to the

brisk exigencies of fashion. The English critic Roger Fry, one of Sargent's most vociferous detractors, seized the occasion of a memorial exhibition at the Royal Academy in 1926 to castigate Sargent's "uniform superficiality of observation." He was, Fry wrote, "transparently honest, sincere, and undistinguished in his reaction to whatever caught his attention."

The apostle of Post-Impressionism—an aesthetic not merely different from but conscientiously opposed to that perfected by Sargent—Fry was caustic and unforgiving. He was unjust to Sargent's virtues, if not necessarily unfair to his limitations. In the years to come, Olson wrote, Sargent "worked his way through the pages of *Who's Who*, then *Debrett* and *Burke's Peerage*, ending up with ample representation in the *Dictionary of National Biography*." His popularity in that world was not won by aesthetic innovation or the searching honesty of his portrayals. Eventually, even the industrious Sargent had had enough. "I have vowed a vow," he wrote to a friend in 1907, "not to do any more portraits." To another: "Ask me to paint your gates, your fences, your barns, which I should gladly do, *but not the human face*." And finally: "No more mugs!"

But in 1882, that disillusionment, that surfeit, was more than a quarter century away. Sargent was just embarking on what was to be a dazzling career. The commission from Edward Boit came at exactly the right moment. *El Jaleo* (1882), Sargent's meticulously exotic picture of a Spanish dancer, demonstrated his adventurousness; his portrait of Louise Burckhardt (1882) demonstrated his innate fondness and sympathy for the world he proposed to embrace with paint and

canvas. The portrait of Edward Boit's daughters offered a perfect opportunity to combine the two.

It is not surprising that Sargent became friendly with the Boits. Edward Darley Boit (1840–1915) was an *echt* Bostonian expatriate: Boston Latin School, Harvard, Secretary of Hasty Pudding, the lot. He was handsome, athletic, and rich—much richer still for his marriage to Mary Louisa Cushing, the only daughter of John Perkins Cushing whose estate "Bellmont" gave the Boston suburb "Belmont" its name. Sargent painted Mary Louisa ("Iza") in 1887: he captured an epitome of bluff and florid good cheer. The Boits were cultivated but, just as important from Sargent's perspective, "agreeably uncomplicated." Their interest in music—they were devoted Wagnerians—formed a bond with Sargent, as did Edward's more-than-amateur interest (though apparently only amateur achievement) in painting. It was an abiding passion. Thirty years later, Sargent joined his old friend in a two-man exhibition of their work in New York.

Sargent had been the star pupil of the French society painter Carolus-Duran (Charles-Emile-Auguste Durand, 1838–1917). He had, however, lately supplemented that tuition with an avid study of other artists, particularly Velázquez, whose work he had assiduously copied at the Prado on a trip to Madrid in 1879. The Boit picture, as Olson noted, was "a deep genuflection" to Velázquez's weird masterpiece *Las Meninas* (1656), "Ladies in Waiting." Just as Velázquez distributed his several figures, including a dog and two dwarfs, asymmetrically around the Infanta Dona Margarita, so Sargent arranged the four Boit girls in a striking tableau in their elegant apartment in the

Avenue de Friedland. This is not a typical family snap-shot, the sitters grouped smiling together in the center of the picture plane; it is Sargent's carefully posed aesthetic ensemble, part homage to Velázquez, part offering to his friend.

The twelve-year-old Jane occupies the center of the canvas. Lips slightly parted, she stands facing the viewer with a frank, gently inquisitive look. Her arms hang loose but decorously at her sides. Like her sisters, she wears black stockings and a white pinafore, a brilliant slip of light in the midst of the hallway's deep shadows. Behind and above her to the left, lost in those inky depths, the silver smudge of a mirror flashes, another allusion to Velázquez's painting.

Directly to Jane's right, the fourteen-year-old Florence stands in profile, facing Jane. Her head swathed in shadows, her hands crossed in front of her, Florence slouches back slightly against a tall Japanese vase, one of two that stand sentry in the picture. The eight-year-old Mary poses further to Jane's right and a bit further downstage. Defining the left segment of the picture, she faces us with hands behind her back, her left foot slightly forward on the wood floor. Her countenance, framed by more-than-shoulder-length curls, is open, pert, amused. Mary's pinafore is another blaze of crisp whiteness, but her knee-length frock is a deep red in contrast to the black that her elder sisters wear.

Closest to the viewer is Julia, age four, a white dumpling still bearing traces of baby fat. Her straight hair, cut in bangs, splashes about her shoulders. She sits with her legs out, feet unselfconsciously pigeon-toed, on a large Savonnerie rug. Facing left, her back parallel to Florence's, she turns to gaze wide-eyed at

the viewer, clasping the doll that she cradles between her legs.

The Daughters of Edward Darley Boit is a remarkable picture. The seven-something-foot square canvas, which now hangs in the Museum of Fine Arts, Boston, is as much the evocation of a stage set as a group portrait of Sargent's friend's four young children. In an enthusiastic piece about Sargent for *Harper's* in 1887, Henry James saved special praise for the "eminently unconventional" work. "When," he asked, "was the pinafore ever painted with that power and made so poetic?"

> The artist has done nothing more felicitous and interesting than this view of a rich, dim, rather generalized French interior (the perspective of a hall with a shining floor, where screens and tall Japanese vases shimmer and loom), which encloses the life and seems to form the happy play-world of a family of charming children The naturalness of the composition, the loveliness of the complete effect, the light, free security of the execution, the sense it gives us of assimilated secrets and of instinct and knowledge playing together . . .

There is in fact a sort of Jamesian opulence about the picture: a spiritual delicacy mirrored by material richness, a civilized world of inflections, nuance, possibility, fullness.

Stanley Olson, who died shortly after his biography of Sargent was published in 1986, described it as "a literary picture; it could support endless interpretation, fascination." He meant this as a compliment, as in the normal course of things it would be. But then it is un-

likely that this lover of Sargent's work had encountered David M. Lubin's influential *Act of Portrayal: Eakins, Sargent, James*, published by Yale University Press the previous year, before finishing his book. The chapter devoted to Sargent focuses on *The Daughters of Edward Darley Boit*. It is an example of "endless interpretation," all right, but interpretation turned rancid. Henry James spoke brightly of the picture's "assimilated secrets." How he would have loathed the "secrets" hallucinated by this academic fantasist. (*Act of Portrayal* is equally surreal about Thomas Eakins's *The Agnew Clinic* and James's own novel *The Portrait of a Lady*.) It is often said that great works of art are "inexhaustible"—capable, as Stanley Olson put it, of "endless interpretation." So they are. But Lubin, the Charlotte C. Weber Professor of Art at Wake Forest University, demonstrates in painful if inadvertently hilarious detail that this does not mean that works of art are immune from—that they are not in fact often subject to—wild and perverse *mis*interpretation.

Today's "interpretive horizon"

It has often been noted that totalitarian ideologies exploit democratic freedoms precisely in order to destroy freedom and abolish democracy. Democratic societies preach tolerance; very well, the clever totalitarian loudly demands tolerance for his own activities while scrupulously obliterating the conditions that make tolerance possible. Similarly, there is a species of hubristic critical ingenuity that exploits the richness of art not to enhance but to violate our experience of art.

Taking advantage of our natural generosity toward art, it perverts rather than extends our understanding. *Act of Portrayal* belongs to this unlovely genre.

Like many recent academic critics, Professor Lubin attempts to disarm his readers by oscillating between the cute and confidential, on the one hand—he's not writing any old boring scholarly work, you see—and the totally outrageous, on the other. He begins by telling us that he aims to show that although the three "texts" he discusses "originated in the 1880s," they were "not completed then, nor are they complete now." Of course, two of these "texts" consist of oil paint on canvas, not words on paper, and so are not "texts" at all, except by courtesy. But let that pass. One still wonders how it is that these works by Eakins, James, and Sargent were suddenly rendered unfinished. They were "complete" until fifteen minutes ago. What happened? How are we to understand Professor Lubin's Incompleteness Theorem?

It used to be that we studied history, including art history, in order to broaden our horizons, to challenge our preconceptions, to get beyond the narrow confines of our present-day culture. That is, we endeavored as far as possible to put aside our contemporary values and prejudices in order to understand the (often very different) world of the past. But Professor Lubin, like so many of his academic confrères, regards the past less as a window than a mirror. He gazes steadily at his subject and he sees—himself. Indeed, Professor Lubin —again like so many of his academic brethren—starts out by declaring that understanding the past is impossible. He doesn't put it quite like that, of course. He speaks instead of "the inevitability" of "cultural, per-

ceptual relativism." He apparently regards such "inevitability" as too obvious to require argument. In any event, he offers no arguments to support what many might regard as an amazing claim. He merely concludes that the best way for us to approach these works of the 1880s by Eakins, James, and Sargent is "with a deliberate and ongoing consciousness that our present needs and values are unavoidably superimposed." Whether the "needs and values" that Professor Lubin embraces can be really described as "ours" is something many readers may wish to dispute. They may also wish to dispute the contention that those "needs and values" are "unavoidably superimposed" upon Sargent, Eakins, and James. After all, many people interested in their work before Professor Lubin arrived on the scene managed to avoid it. But no one reading this book will doubt that Professor Lubin has done a thorough job of superimposition.

Professor Lubin's "needs and values" form a familiar menu. Sargent inhabited and described the confident haute-bourgeois world of the late nineteenth century. He celebrated that world: its wealth, its beauty, its culture, its civilized amplitude. He loved its vigor as much as its delicacy, its range as much as its concentration. Professor Lubin's primary "need" is to undermine and pervert the world that Sargent (as well as, in their different ways, Eakins and James) sought to preserve and affirm. He calls his book "act of portrayal." The play on "act of betrayal" is patent. The aim or end of Professor Lubin's betrayal is to discredit, to render unchaste and sordid, everything his subjects celebrated. The means he found in the corrosive armory of critical sophistry.

Professor Lubin approaches the task of betrayal in stages. With respect to Sargent, his first aim is to disorient the viewer. As Henry James and Stanley Olson noted, the painting is instinct with not only a sense of sumptuousness but also an aura of mystery. It is a pleasing mystery: those "assimilated secrets" of which James spoke are decorous secrets. So the first thing that Professor Lubin sets out to do is to convince us that *The Daughters of Edward Darley Boit* isn't at all the charming domestic scene we thought it was. Perhaps you felt that the painting communicated a gratifying complacency: four attractive American girls at home in the well-appointed comfort of their Paris apartment. What's not to like? No, no, no, says Professor Lubin, what Sargent has really pictured is an unhappy psychodrama fraught with exploitation, anxiety, and tension. It doesn't matter, he tells us, "whether Sargent meant it this way or not."

Consider those two tall Japanese vases. I thought they looked pretty nifty. But for Professor Lubin, they show that the painting portrays the girls in a doll's house—indeed, in *A Doll's House*, since no sooner does the analogy occur to him than he's off comparing Sargent's painting with Ibsen's unhappy play (he also throws in *Alice in Wonderland* and *Gulliver's Travels* for good measure). According to Professor Lubin, the four girls in Sargent's painting are "eerily dwarfed" and look like "prisoners in Bentham's Panopticon," a prison arrangement in which the occupants are always exposed to the surveillance of their keepers. "These girls," Professor Lubin warns, "are stranded within a doll's house, a world of property and propriety that truly overwhelms them."

Really? Do they look overwhelmed to you? Look at the plate. To me, they look perfectly content—and why not? Why should such comfortable "property and propriety" overwhelm them? Indeed, why does Professor Lubin have a "need or value" to use those words as negative epithets? What's wrong with propriety? As for the Japanese vases, do they really "dwarf" the girls? The MFA generally exhibits the painting with two similar vases standing on a platform on either side of the painting. Sure, they're tall; they're impressive. But to my eye they add merely another accent of opulence to the picture. Far from dwarfing the girls, they enrich the world they inhabit by providing another expensive, slightly exotic accoutrement to embellish their setting.

Professor Lubin says that by "miniaturizing" the girls the painting "can be seen as exaggerating the notion of woman as a diminutive person." Ah yes, our old friend "Can Be Seen As"! (See above, pages 44 and 69.) Well, what about someone who says that by *not* miniaturizing the girls the painting can be seen as highlighting the notion of the critic as a diminutive person?

Then there are Ibsen, Lewis Carroll, et al. Where in heaven's name did they come from?* Clearly Professor Lubin felt a little anxious on this score, for he tells us that "Regardless of whether Sargent had the Carroll novels or the Ibsen drama in mind," it's perfectly OK to bring them into the discussion because "Alice and Nora are part of the cultural landscape determining our present-day interpretive horizon." Eh? "Interpre-

* It is true that Mary looks not unlike some of Tenniel's drawings of Alice, but that is because both are clad similarly and sport hair styles typical of their class and time: they resemble each other because they resemble thousands of other little girls of the period.

tive horizon" is a nice phrase, an impressive phrase. Students of Dilthey and Heidegger will enjoy a warm feeling of recognition while contemplating it. But what about the "interpretive horizon" of Sargent's day? I mean, plenty of things are part of *our* interpretive horizon: hamburgers, television, the Second World War, the moon landing, bogus novels by Norman Mailer or Jacqueline Susann, silly academic art criticism, and a thousand other things. Shall we look for them all in Sargent's picture? How about the influence of Martha Stewart on the girl's clothing? Or the Japanese surrender in 1945 on the placement of those vases? By giving priority to "our present-day interpretive horizon," Professor Lubin transforms Sargent's painting into a receptacle for our—at least, for Professor Lubin's—"needs and values." What if you were, just for the moment, more interested in Sargent's painting than in Professor Lubin's "needs and values"?

Of course, the needs and values of Professor Lubin's interpretive horizon extend to his subjects as well as their works. You might think that the chief interest in Eakins, James, and Sargent would be in what they *did*: the paintings Eakins and Sargent painted, the novels and other things James wrote. But it is one of Profesor Lubin's needs and values to expatiate at considerable length on their sexuality—or, rather, on what he imagines their sexuality must have been. He goes through the now standard lullaby about "repressed homoerotic tendencies," etc., etc. Their lives, according to Professor Lubin, "were filled with a deep-seated, deeply hidden sexual ambivalence." But not, note well, so deeply hidden that a bloodhound like Professor Lubin—or any non-comatose graduate student of the last forty

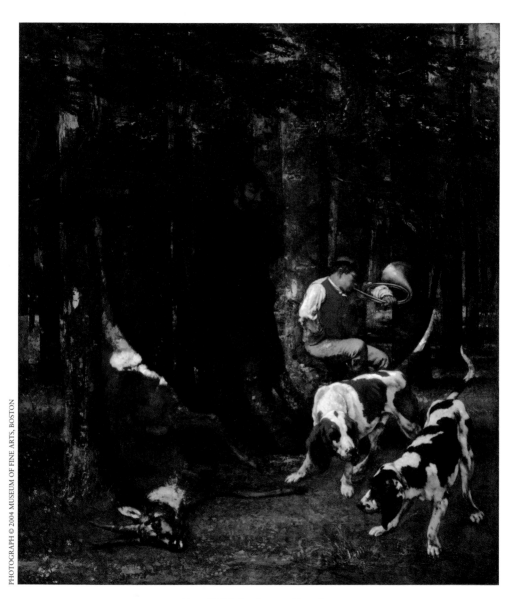

Jean Désirée Gustav Courbet
The Quarry (La Cúree), 1856

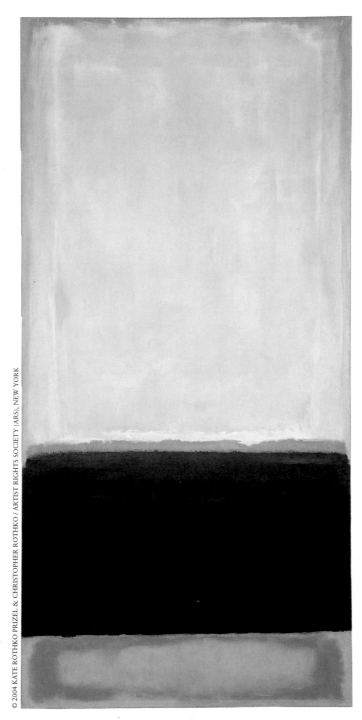

Mark Rothko
Untitled, 1953

John Singer Sargent
The Daughters of Edward Darley Boit, 1882

Peter Paul Rubens
Drunken Silenus, 1618

Winslow Homer
The Gulf Stream, 1899

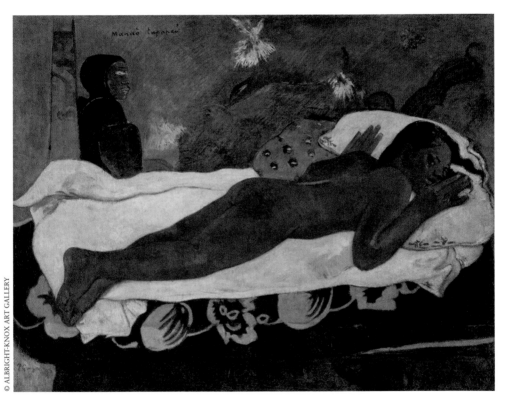

Paul Gauguin
Spirit of the Dead Watching, 1892

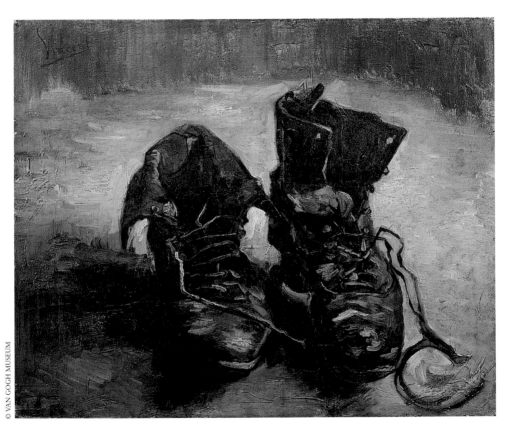

Vincent van Gogh
A Pair of Shoes, 1886

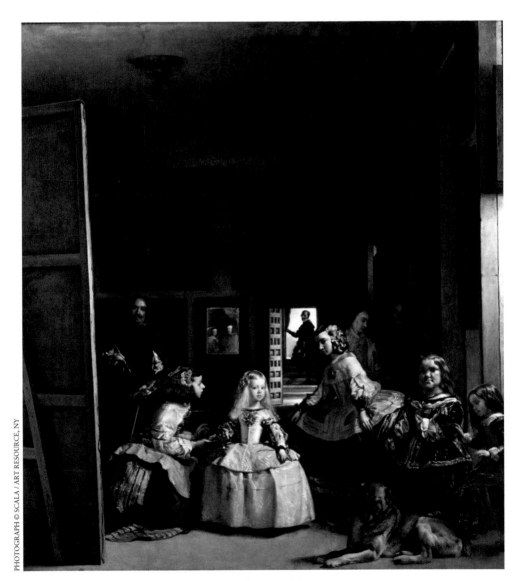

Diego Rodriguez Velazquez
Las Meninas, 1656

years—can't find and publicize it. You might have thought that when he painted a portrait, Sargent was, well, *painting a portrait*. How naïve. According to Professor Lubin—what a daring thought!—for all three of the artists he discusses,

> Portraiture was a testing out, an acting out in sublimated form of the artist's own sexuality. It was a means of declaring the otherwise indeclarable, a method of externalizing and temporarily reconciling that highly unstable, even volatile, sexual difference that was felt within but not understood.

Imagine someone trying to pass off this sclerotic Freudian rubbish in 1985! It is almost enough to make one speculate on what highly unstable, even volatile "needs and values" Professor Lubin was acting out in sublimated form by publicly airing such sophomoric psychological theorizing.

A campaign for decivilization

In his effort to sexualize everything, Professor Lubin is behaving no differently from many other contemporary academic art historians—remember Michael Fried and that unfortunate roe deer? But it is worth noting that although the treasure hunt for sexual motifs is deeply indebted to Freudianism, its aim is rather different from that of Freud's original practice. For one thing, our own society is positively saturated with *overt* sexual content: we don't need Freud to draw our attention to hidden sexual themes because we don't

believe in hiding anything these days. For another thing, Freud actually believed he was explaining something real, albeit hitherto hidden. He may have been wrong. I believe that in almost all cases he *was* wrong. But he endeavored to use his theories to reveal something about the psychological reality of whatever it was he was writing about.

In contemporary literary and art history, by contrast, the sex card is generally deployed primarily as a *weapon*. It is used first and foremost to "challenge" or "transgress" the traditional fabric of manners and morals that stands behind whatever literary or artistic work is under discussion. The enemy is only incidentally the particular work in which hidden, generally outré, sexual themes are "discovered." The real enemy is the received social and moral sensibility out of which the work emerged and in which it has its original meaning. Thus it is that the shocking sex stuff is always part and parcel of an effort to "destabilize" the hegemony of "white patriarchal capitalist" blah blah blah. Indeed, a useful study might be made of the way in which the normalization of previously tabooed sexual attitudes and behaviors has been at the forefront of cultural radicalism since the 1960s. Sex is merely the first bridgehead, the easiest point of entry. In this sense, much of what travels under the banner of sexual liberation is really part of a campaign for *de-civilization*. You see it at work as much in the coarsening of pop culture and the increasing vulgarization of formerly "polite society" as you do in the anemic if frenzied sexualization of academic language in the humanities. What it marks is not the triumph of the erotic but the defeat of reticence and modesty—reser-

voirs of hesitation and scruple that, ironically, are preconditions of any vital and humane erotic life.

But to return to Professor Lubin and his "needs and values." He begins his discussion of *The Daughters of Edward Darley Boit* by assigning each of the girls a letter of the alphabet. He refers to them by letter instead of by name because, he says, there is nothing about the picture itself to tell us what their names are. Now this might be—yes, I think it must be—the single funniest moment in Professor Lubin's entire book. For when it comes to populating works with items from elsewhere, Professor Lubin might as well be running a wholesale import business. And yet he insists on referring to Julia, Mary, Jane, and Florence by the initials J, A, I, and R when, like me, he could have just looked up their names. After all, he looked up plenty of other things. And many of the things he didn't look up he simply made up. About the littlest girl, Julia ("J" to Professor Lubin), for example, he writes that "She must be viewed as part of the rug, its condensation and culmination perhaps." While you try to work out what it could possibly mean for a little girl—for anyone—to be the "condensation and culmination" of a rug, let Professor Lubin tell you about the doll between her legs. It "forms a sort of buffer zone," he says,

> that obstructs both the head-on gaze of the viewer and the direct approach of light from the painting's lower left corner. What this buffer zone protectively blocks from our gaze and from the revealing light is J's pudendum, as though to disclaim it, deny it, forswear its existence. J may thus . . . be characterized as thoroughly presexual and wholly unavailable to sexual

investigation, whether scientific, artistic, or prurient. Nevertheless, that she protects her genital zone reflects how deeply sexualized she is, or how effective an act of repression this painting . . . must achieve in order to abide by an ideology of sexual innocence.

Yes, yes, I know: pity wars with contempt—and it loses, doesn't it? This sort of thing really is beneath comment. I'll pass it by myself—except to note that poor Julia is not "protecting" anything. She is sitting there biddably on a rug with her sisters behind her. Nor does Sargent's painting "repress" anything. Rather it *expresses* his delight in skilfully rendering an attractive domestic scene, "the happy play-world," as James put it, "of a family of charming children." And as for the "ideology of sexual innocence," that is simply another one of Professor Lubin's discount imports. Only for a mind steeped in sex would the absence of any overt sexual content point suspiciously toward an "ideology of sexual innocence." For Sargent—and for those viewing his picture in the 1880s—the subject never entered the discussion: not because it was repressed, but because it was irrelevant to the matter at hand, as irrelevant as the mean temperature of Siberia, the migratory patterns of Canadian geese, or what it takes to receive a named chair in the history of art at Wake Forest University.

Professor Lubin vacillates between discussing each of the daughters on her own and amalgamating them into a single entity he calls "the Female Child." On the one hand, Jane ("I" to Professor Lubin) is said to display open lips that "form an oval, an O, an ingestive hole, a pocket, cavity, wound," on the other we are told that

"The painting offers not one but several texts in the nature and social reality of this particular Female Child, the pre-adult female of a particular class (upper), race (white), place (refined Europe or America)."

As we've noted, the painting doesn't offer a text at all. (Why is the distinction between something written and something painted or drawn so difficult to assimilate? We read texts—formerly known as "books." We look at paintings. Remember Bishop Butler from the Introduction: "Everything is what it is, and not another thing.") The confusion of texts and paintings is part of a general procedure that has two basic aims: one, to make works of art more nearly like the things academic art critics are most used to dealing with, i.e., "texts." And two, to make the art work as unpleasant and off-putting as possible. Alice Roosevelt Longworth is said to have remarked: "If you don't have anything nice to say, come sit by me." That's one of the mottos of the new academic art history. Professor Lubin accomplishes this task partly by inserting gross biological terms whenever he can. So Jane's slightly open lips—part of the look of quizzical intelligence that Sargent caught—become "an ingestive hole, a pocket, a cavity," etc. Robert Burns might have thought that his love is like a red, red rose; Professor Lubin reminds us that her lips are part of an alimentary tract. Professor Lubin also misses no opportunity to dissipate the overall charm of the picture by indulging in a patter of vaguely menacing, quasi-Marxist class-race-gender talk. Edward Boit's status as rich, white, American, male is subtly—well, insinuatingly, anyway—held against him and his family. We are meant to think less of him for those attributes.

Beyond the bounds of credibility

It is amazing to contemplate, but in all this Professor Lubin was just warming up. The real gravamen of *Act of Portrayal*—the thing that Professor Lubin is clearly proudest of and the thing that made his book such an academic hit—is the giddy word play he delights in on the name "Boit." Indeed, one wonders whether he scoured Sargent's oeuvre not for a good or moving or attractive or beautiful painting, but one that, with determined critical aggressiveness, could be made to serve as a prop in his hermeneutical hothouse.

Professor Lubin's first point is that the French word for box, *boîte*, is only one letter and an accent mark away from the surname of the painting's subject: "Boit." "*The Boit Children* makes a visual-verbal pun by translating into *Les Enfants de (la) Boît(e)*: the children of Boit and the children of the box." In fact, it is not the *painting* that makes the pun—and a silly enough pun it is—but Professor Lubin. And that's just the beginning of his charade. "Another way of accounting for the overall emptiness or lack that the painting bespeaks," Professor Lubin intones, "is that the Female Child enclosed within this geometric and ideological box is also trapped within a biological box: the lack of the father's E, his penis."

Bring you up short, did it? Perhaps you're thinking that the real issue here is not the totally fortuitous and irrelevant similarity between the surname "Boit" and the French word for "box" but the much more pertinent congruence between "Boit" and the third person singular of the French verb *boire*, to drink: *il boit*, he drinks, he is a drunkard, sot, lush, tippler.

You feel that Professor Lubin knows he is straining here, for he hastily issues one of his periodic disclaimers: "Why in the world," he asks, "have I equated the Boit's father's first initial, the letter E, with the male organ?" An excellent question, that. We don't get a satisfactory answer but rather a flurry of persiflage about how "it is less ironic than predictable that in French, *boîte* is a feminine gender noun." It is also less ironical than predictable that a present-day academic would assimilate the grammatical category of gender to the biological category of sex. What we call "gender" in grammar often has but a tenuous relation with sexual identity. Thus for example the German word for young girl is *das Mädchen*, a neuter noun. Professor Lubin says that "Sargent's portrait not only uses the devices of realist representation to depict Boit's girls as feminine, but also doubles the depiction by enclosing them within a superstructure for which the French term is feminine." Er, not quite, professor. Sargent represented Edward Boit's daughters "as feminine" because—how can I put this?—the people he was painting were little *girls*. I know that is a difficult thing to get one's mind around, but with patience Professor Lubin will discover that little girls are often, indeed regularly, "represented as feminine." With a little practice, he may even discover why this is so.

Professor Lubin readily admits that "It far oversteps the bounds of credibility to think that Sargent had any of this in mind before, during, or after he painted the painting." "For this relief, much thanks"! (*Hamlet*, I:i) But then he cheerfully tells us that, notwithstanding what Sargent thought, we shouldn't be surprised "if somehow a psychic transfer or transmutation occurs

between the verbal part of the creative mind . . . and the visual part." Psychic transfer? Transmutation? What is this, Shirley MacLaine meets art history? Which would be stranger, a new-age psychic on this subject, or Professor Lubin with his conviction that the captial "E" in the name "Edward" has something to do with the male organ while the little "e" represents (among other things) the clitoris. No, I am not making this up:

> What are the differences between big E and little e? To start, one is "big" and the other "little." One is all hard right angles, straight and erect, while the other contains no straight angles but instead is softly curvilinear. One outwardly projects its elements, including that smaller, centrally placed appendage with which E would be reduced to an unclosed (unmated) bracket, a "[," while the other tucks itself inward: is involuted; is, yes, womblike. (Or, if one prefers, clitoral: Webster's phrase for the clitoris: "a small, erectile organ at the upper end of the vulva" [thanks for the information, Professor] is neatly matched by the look of the letter e.) The uppercase letter, being a capital letter, is regarded as superior to the lowercase letter, thus enacting on a typographical level not only the upper-versus-lower class differences that inhere in a capital-ist [sic] economic system, but also in a society such as the one *Boit* depicts, in which, in terms of the sexes, there is a pronounced class (or case) difference between the fathers and husbands, who possess capital (be it financial or spermatic), and mothers and wives, who do not. Finally, E is an initiator, a letter used for starting sentences, while in French, e is a letter whose proper place, when it comes to feminine nouns, is to go behind.

As it happens, Mrs. Boit, the former Miss Cushing, possessed a good deal more capital than her husband, but pointing that out would spoil the beautiful fairytale Professor Lubin has spun for us, so let's pass over that in silence. Professor Lubin's pride in his ingenuity is almost palpable. I felt it most when he tells us that capital letters begin sentences: how very significant! And I am sure that Professor Lubin would appreciate being reminded that *lubie,* the French for "whim" or "fad," is only one letter away from "Lubin." I hope he will have occasion to meditate on that fact in his next book.

Professor Lubin has a lot more to say about the Boit/Boîte connection. The one bit I feel I must share is his fugue on the circumflex over the letter "i." In French, as Professor Lubin notes, a circumflex denotes the fact that the letter "s" had at one time been part of the word in question. For Professor Lubin, that is a deeply titillating fact.

> The circumflexed *i* of boîte marks the absence of an *s,* the letter in the alphabet that not only commences the word sperm, but also resembles the sperm cell, the spermatozoon. . . . One of the roles of the letter *s* is to make a singular word plural; thus not unlike sperm, *s* can have a reproductive function.
>
> The circumflex, inasmuch as it elides letters, makes words into contractions—a term that, outside the realm of grammar, has its own special place in the lingo of childbirth. Indeed, the circumflex, as typographical marking, can be seen in its own right as sexual, though now in a distinctly feminine, maternal way: as a sheltering tent; a bosom; a receptacle into

which the central letter of boîte, the *i*, is phallically plunged. . . . In the word *boîte*, the letter *i* has lost its rounded head in exchange for a spearhead; now it bears resemblance to an erect male member, the circumflexion producing the look of circumcision.

This leads Professor Lubin to his denouement. An "i" with a circumflex, he points out, linguistically equals the letters "i" and "s." The letter "i" he has already identified with Jane, the Boit daughter standing at the center of the picture, while "s" he has identified with sperm. "Therefore"—yes, he really says "therefore"— "î = fertilized female, which, to the extent that a woman impregnated is a woman whose personal freedom and potential has been clipped, may also be to say î = circumcised female." All of which leads him to the conclusion that "in the present context" "procreation, artistic as well as biological, is . . . the central theme of *The Daughters of Edward Boit*." Clearly, Professor Lubin is not the sort of chap you want to leave alone with an underaged circumflex.

EARLIER IN THIS BOOK I mentioned Ronald Knox's essay "The Authorship of *In Memoriam*." In this spoof, Knox pretends to prove that the real author of Tennyson's poem was Queen Victoria.

One looks, naturally, for a cryptogram. And here a most impressive fact meets us at the very outset of the inquiry. Give the letters their natural value as Greek numerals: that is, make A = 1, E = 5, I = 10, M = 40. . . . The Letters of *In Memoriam* thus work out at 10 + 50 + 40 + 5 + 40 + 70 + 100 + 1 + 40, cyphers which

on a careful computation add up to 366, the number of days in the full year! Again, if you give the vowels their natural values as a separate series, this time making A = 1, E = 2, etc., you find that the vowels IEIOA represent 3 + 2 + 2 + 4 + 1, cyphers which add up to the mystical number 13. Adding 100 to 13 (for want of anything better to do), you arrive . . .

well, you arrive at an amusing satire. "The implication is plain enough; the author of this poem is not its reputed author; somebody described as H. M. is really writing the poem," i.e., Her Majesty. "Astounding— impossible! . . . And yet, is it so extraordinary? [A]t that period of our history, though a woman might write poetry, a queen might not publish it," etc., etc. Knox is far cleverer at this sort of thing than Professor Lubin, though also far less obsessed with sex.

Expatiating on the Female Child and Julia's doll, Professor Lubin tells us that she stutteringly called the doll "P-paul." That name, he says, elides to "papa." "We are encountering a condensation of linguistic signifiers as well, *pa* being the letters that commence a number of words central to our consideration of this portrait: papa, pater, patron, painter." But what about painfully pathetic pathological pap? Why doesn't "P-paul" "condense" to something like that?

In the midst of his little fantasy about the word *boîte*, Professor Lubin's tells us that among its many meanings is a house of prostitution. This leads him to speculate that Edward Boit, though not actually in the picture, "is thus"—*thus*, mind you—

figured in absentia as the master or boss of these young

females whom the title designates as his children but who, seeming to await his slightest word or wish, might also be thought of as his servants, his domestics, and even, at the level of submerged sexual fantasy, as his harem, his congregation of wives, his jolies fillettes du bordel/maison/boîte.

Professor Lubin admits that Sargent "did not set out to liken the children of his friend and patron to well-tended slaves or pampered young courtesans lounging in the foyer of a bordello"—thanks for that, Professor! But he nevertheless insists that "close analysis of the painting's visual and verbal semantics makes such a reading viable." Indeed, Professor Lubin repeatedly assures us that "close observation," "close reading," or "close analysis" yields the surprising but—to the eagle-eyed hermeneut—"viable" interpretations he offers here. In fact, though, the one thing completely missing from Professor Lubin's account of *The Daughters of Edward Darley Boit* is close reading or close analysis. What he offers instead is gross fantasy that *parodies* close reading in order to produce an utterly grotesque caricature of interpretation. It's "close reading" as imagined by Hamlet: "there is nothing either good or bad but thinking makes it so." Professor Lubin's word-intoxicated, politically correct assault on Sargent's painting is meant partly to demonstrate how clever he is and partly to make it impossible for us to enjoy the painting on its own terms. Fortunately, Sargent survives the assault unscathed. The same cannot be said for the Charlotte C. Weber Professor of Art at Wake Forest University.

Chapter 4
Inebriating Rubens

This is the very coinage of your brain.
—Gertrude, *Hamlet* III: iv

"The Apelles of our age"

I F WILLIAM BLAKE was right that "Energy is eternal delight," then the Flemish painter Peter Paul Rubens (1577–1640) must have had claim to great happiness. The man was a prodigy of energy. He was also a great catalyst for energy in others: one of those men whose example sparked and nurtured emulation.

Resourcefulness was a birthright. Rubens's father, a Calvinist, had fled with his family from Antwerp to Cologne in 1568 to escape religious persecution. Jan Rubens was heterodox in more than his theological opinions. In Cologne, he became a legal advisor to Anne of Saxony, the estranged wife of William the Silent. As one commentator observed, "the unfortunate and unbalanced princess, 14 years his junior, made immoderate demands first on the time of her lawyer and then on his fidelity." When Anne was discovered to be

pregnant, Jan was imprisoned. He might have been executed. But Maria, his stalwart and forgiving wife, waged a successful (and expensive) campaign to win his release.

The family moved to Siegen, Westphalia, where Peter Paul was born in 1577, the sixth of seven children. When Jan died, in 1587, the family returned to Antwerp and to Roman Catholicism. Educated by the Jesuits, Rubens was as worldly as he was devout—or perhaps I should say he was as devout as he was worldly, for this talented and purposeful artist became a devoted servant in the cause of the Counter-Reformation. (Interesting tidbit: In 1599, half of Europe was Protestant; by 1650, only 20 percent was.) Rubens early on distinguished himself as an excellent linguist—he became fluent in five languages—and as a student of classical literature. By the age of twenty-one, he had also become a master painter. In later years, he became an avid collector, amassing an impressive collection that included several works by Titian, Tintoretto, and Veronese. When he died, in 1640, he was justly commemorated as "the most learned painter in the world."

In 1600, Rubens went to Italy, where for eight years he was court painter to the Duke of Mantua, a position that did not prevent frequent trips to Rome, Genoa, and other important Italian cities. In 1603, the Duke sent him on a good-will mission to Spain. Rubens's talent as a diplomat was already almost as highly prized as his artistic skill. A master of ingratiation, he often expended more time negotiating international treaties than painting. He was as at home among kings and princes and ambassadors as he was among artists. In 1630, Charles I

of England knighted Rubens for the role he played in brokering a peace treaty between England and Spain; he also commissioned Rubens to paint the *Allegory of War and Peace* for the ceiling of Banqueting House in Whitehall Palace. Artist, scholar, diplomat, art collector: Rubens excelled at whatever he touched. "Possibly more than any other artist," wrote the Rubens scholar Christopher White, "he could claim to be the *uomo universale* of his epoch."

In October of 1608, Rubens got word that his mother was gravely ill. He returned to Antwerp only to find that she had died some weeks before. He decided to resettle himself in Antwerp and before long had married Isabella Brandt, a niece of his brother Philip's wife, and soon established himself as the first painter of the city. Rubens and Isabella had three children and by all accounts were extremely happy. When Isabella died in 1626, Rubens grieved but did not repine. Whatever solace his adherence to the principles of Christian Stoicism failed to provide, his healthy pragmatism made good. In 1630, at the age of fifty-three, he married the sixteen-year-old Helena Fourment, by whom he had several children and whose engaging blond sensuousness Rubens often celebrated on canvas.

Within a few years of returning to Antwerp, Rubens was being hailed by contemporaries as "the Apelles of our age," comparison with the fourth-century B.C. Greek painter being regarded as the zenith of praise. On top of everything else, Rubens was an exceptionally able administrator and entrepreneur. Over the course of three decades, his workshop (among whose "graduates" was Anthony van Dyck) turned out an astonishing 2000 works, furnishing churches and palaces

across Europe with scores of paintings, frescoes, altar-pieces, and tapestries.

Nevertheless, Rubens's enormous reputation has long been shadowed by reservations. On the one hand, he is one of the most commanding and exuberant painters on record. Delacroix, himself no slouch in this department, wrote often and admiringly in his *Journal* of Rubens's dash and energy—"that indefinable thing which belongs to him alone." On the other hand, the price of that exuberance was sometimes lack of refinement. Henry James registered this scruple when he noted that Rubens "belongs, certainly, to the small group of the world's greatest painters, but he is, in a certain way, the vulgarest of the group."

James at least responded to Rubens's power. Not everyone has. Thomas Eakins, for example, famously wrote in a letter to his father that "Rubens is the nastiest most vulgar noisy painter that ever lived. . . . His pictures always put me in mind of chamber pots." If Eakins's response is extreme, it is consonant with a common understanding of the adjective that Rubens has bequeathed to the English language. For many, "Rubensesque" connotes pink and adipose flesh, brazenly naked, generally female, the dispensation of mythological or Biblical subject matter only partly compensating for the gross blowsiness set down on canvas. Rubens is always adduced when someone wishes to give us a lecture on how fashions in female beauty change. Today we admire slimness, but (it is said) the plump damsels populating Rubens's pictures demonstrate that fleshiness and lots of it was once upon a time the thing.

Perhaps so. But notwithstanding the caloric ecstasy of some of Rubens's personages, we shouldn't discount

the extraordinary elegance of some of his painting. H. W. Janson in his *History of Art* noted that Rubens had "finished what Dürer had started a hundred years earlier—the breakdown of the artistic barriers between North and South." What he meant was that Rubens managed to marry the sumptuous color of Titian and Veronese with the more astringent geometries and drier palette of the Netherlandish tradition. Rubens, as one commentator observed, "carried the image of Titian in his mind as a lady carries that of her beloved in her heart." In many of Rubens's portraits—the picture of Veronica Spinola Doria (*c.* 1606–7), for example, or the *Self-portrait with Isabella Brandt* (*c.* 1609–10)— excess is absorbed or subsumed or balanced by great delicacy. The result is painting that is both gorgeous and decorous.

Nevertheless, one knows what Eakins, or at least what James, had in mind. For if Rubens painted works of supreme elegance, he was also capable of producing works of striking earthiness. There is in some of Rubens pictures a certain *teeming* quality, a ripeness that teeters towards rancidness. A case in point is *Drunken Silenus* (1618). This six-and-a-half-foot oil-on-panel picture, now in the Alte Pinakothek, depicts the inebriated companion of Dionysus lumbering naked and unsteady through the woods, half supported, half goaded by his giddy retinue of satyrs, crones, nymphs, and goats who bustle around behind him. Flabby, bald, and bearded, crowned with a disheveled garland, Silenus lurches forward wearing that risible look of fierce but vacant concentration which vinous overindulgence exacts in the performance of basic motor activities. The fingers of his right hand close loosely around a luscious bunch of

grapes. Behind him, a black man grasps and pulls up on his left arm at the elbow to support the tottering figure while at the same time he naughtily grabs and pinches Silenus's left thigh. In the left foreground, an ample and brilliantly illuminated satyress crouches forward on her knees to suckle two infant satyrs whose lips tug greedily at her swollen dugs. The painting pulses with a sense of blind animal fecundity.

Silenus is a minor and ambiguous personage in the pantheon of Greek mythology. Corpulence is a frequent trait, drunkenness and a talent for musical enchantment invariable ones.

In Plato's *Symposium*, Alcibiades compares Socrates to "those little sileni you see on the statuaries' stalls . . . modelled with pipes or flutes in their hands, and when you open them down the middle there are little figures of the god inside." Like them—or like the satyr Marsyas—Socrates bewitches mankind with music, the music of his arguments and personality. In Virgil's sixth *Eclogue* two lads surprise Silenus sleeping it off in a cave, "his veins swollen, as ever, with the wine of yesterday." They bind him with his own garlands and the beautiful Naiad Aegle "paints his face and brows with crimson mulberries" as he wakens. Silenus promises to sing the songs the boys crave and to give Aegle "another kind of reward" if they free him. Virgil devotes the rest of the eclogue to evoking Silenus's recital. In *The Birth of Tragedy*, Nietzsche presents a darker side of Silenus. Drawing partly on a passage from Sophocles' *Oedipus at Colonus*, he tells the "ancient story" of how King Midas hunted Silenus and, finally capturing him, asked what was best and most desirable for mankind. Silenus gave a nasty laugh and

said that what would be best was impossible—never to have been born—but second best was "to die soon." This is what Nietzsche calls "the wisdom of Silenus" —a "wisdom," one might observe, that is characteristic of someone chronically plagued by a morning head.

What was Rubens's interest in Silenus? In general, it was the same as his interest in Prometheus, Hercules, Iphigenia, and all the other figures from the panoply of Greek and Roman mythology that he drew and painted. Silenus was a colorful character who provided good material for the visual drama of Rubens's art.

Silenus also provided a ready-made moral about the liabilities of bibulousness. Rubens was notably, almost notoriously, a temperate man. In his letters, he frequently registers his aversion to the excesses of the table—indeed, to excess of any sort. Rubens's paintings may have been lush, fleshy, exuberant. Temperamentally, he was attracted to the equabilities of Stoicism. He was moderate in all things except immoderation. "One must pray for a sane spirit in a healthy body, for a courageous soul, which is not afraid of death, which is free of wrath and desires nothing." Rubens had these words from Juvenal's *Satires* chiseled on an archway at his studio in Antwerp: they could serve as his motto. "One of the most attractive features of Rubens," Christopher White noted in his study of the painter, "and indeed one which contributed so enormously to his general happiness of life, was his self-knowledge." So far as we can tell, introspection was not part of his agenda. He did not fret, he did not brood; he acted. Deliberateness and dispassionateness were his bywords. "As for me," Rubens slyly wrote to a friend, "I assure you that in public affairs I am the most dispassionate

man in the world, except where my property and person are concerned."

In short, Rubens was one of those rare characters in which the public figure and the private man coincided. What you saw was what there was: Prosperous artist, effective diplomat, fond brother and husband, canny businessman. As White put it, he "stands apart from the rest of humanity as a very great man almost without any dark corners in his make-up."

Rubens as Silenus?

I mention these details because the Rubens of history is a very different character from the strange personage Svetlana Alpers conjures up in her book *The Making of Rubens*. This brief study, published by Yale University Press in 1995, attempts to enlist Rubens as a tortured postmodern sexual adventurer, deeply if somewhat unwittingly concerned with issues of gender identity and feminist ideology.

When she published *The Making of Rubens*, Svetlana Alpers was not a promising young star on the way up the academic firmament as was David Lubin when he wrote his study of Sargent, James, and Eakins. She was already an established eminence, for many years a professor of art history at the University of California, Berkeley, the founding editor of the trendy journal *Representations*, an editor of *Raritan* (another trendy journal), author of several highly regarded books on seventeenth-century Flemish art, and doyenne of an influential mode of subjecting art history to the imperatives of postmodern theory. It is ironical, then, that

Alpers first made her reputation some thirty-five years ago in the *Corpus Rubenianum Ludwig Burchard*, the magisterial, many-volumed *catalogue raisonée* of Rubens's vast oeuvre. Her contribution, *The Decoration of the Torre de la Parada* (1970), is a model of patience and careful scholarship about the monumental cycle of works that Rubens designed for Philip IV's hunting lodge near Madrid towards the end of his career.

But that was then. By the late 1980s Alpers had traded tradition for trendiness. In her book *Rembrandt's Enterprise: The Studio and the Market* (1988), for example, Professor Alpers is at pains to show that Rembrandt was fundamentally "a man of the market," a "*pictor economicus*," who identified art with money and thus was instrumental in "making art into a commodity" and indeed "commodifie[d] himself" in his art. In other words, Rembrandt the artist is shelved in favor of a neo-Marxist exercise in social history.

In *The Making of Rubens*, Professor Alpers shifts from economics to sex. This is evident even in her book's title. The word "making" refers partly to the process whereby Rubens became Rubens; but it also slyly carries an implication of sexual conquest. The deliberate ambiguity is something that Professor Alpers, like so many trendy academics today, gleefully exploits. She employs the story of Rubens's career as an alibi for her project of artistic gender reassignment.

This ambition is evident throughout *The Making of Rubens*, but especially in the third and last chapter, "Creativity in the Flesh: The *Drunken Silenus*." In this chapter, Professor Alpers dilates on what she considers "Rubens's own sense of identity and gender," weaving a Gothic tale about the painter's psychosexual makeup

and his relation to the figure of Silenus. Professor Alpers begins with some seemingly innocuous questions, e.g., "how did Rubens embody himself in his painting?" Well, what if the answer is, "Rubens didn't 'embody himself' in his painting, he merely depicted a character from Greek mythology"?

Professor Alpers doesn't consider that possibility. Instead she tries to convince us that Rubens had a "fixation" on Silenus. She even describes the painting as "a wellspring of his art." Why? Because he painted the figure of Silenus "a surprising number of times." Really? What made it surprising? After all, Rubens, like many artists, painted and drew most of the characters he included in his pictures multiple times. What is surprising is the unflagging energy he brought to subjects no matter how often he draw or painted them. The image of Silenus wins no contests for frequency.

Professor Alpers approaches the *Drunken Silenus* with an impressive wagonload of scholarship. Although she notes in passing that the painting is "directly related to no text," she nevertheless attempts to impress us with the influence of Virgil's sixth *Eclogue* on Rubens's conception of the painting. In an earlier chapter I mentioned what might be called the Austin two-step, after the philosopher J. L. Austin's quip that "there's the part where he says it, and the part where he takes it back." It's a popular gambit. First you acknowledge that there are little or no grounds for asserting X; then you assert it anyway, counting on your ability to fall back on the previous admission if you are taxed too severely with the groundless assertion.

Thus Professor Alpers: she notes that Rubens was "a

notably moderate man." Then she proceeds to identify him with a figure that epitomizes louche intemperance. Again, she admits that *Drunken Silenus* was not indebted to any literary text. Then she goes on to identify Rubens's Silenus with Virgil's.

> My sense is that Rubens's notion of Silenus results from informing the body of the fleshy bacchic figure he found in art with the account of Silenus as ecstatic/ Orphic poet he found in reading Virgil. This suggested to him a physical embodiment of an abandonment to making/creating with which he could confront the condition of the poet/maker, and specifically the condition of men as makers.

Rubens, avid reader of the classics that he was, undoubtedly knew Virgil's poem. But as the Rubens scholar Christopher Brown drily noted in a review of *The Making of Rubens* in the *TLS*, "There is no evidence to support this interpretation." Professor Alpers argues that

> Silenus, for Rubens, is not the conscious creating of an outlet or voice . . . but the embracing and figuring forth of a particular situation or creative state. This is the imagined site (the metaphor is that of the studio) of Rubens's creating: drunken, tied down by a pair of shepherds/satyrs and, as his brow is stained by a nymph, waking and beginning his extended song. Silenus embodies an ecstatic notion of creating art.

Well, "an ecstatic notion of creating art" sounds very nice. But what does it have to do with Rubens? His

Silenus, unlike Virgil's, is not bound by a couple of passing lads who wanted to hear him sing. Rubens's Silenus, unlike Virgil's, doesn't have his brow stained by a beautiful Naiad after whom he lusts. Rubens's Silenus, unlike Virgil's, isn't singing. In fact, Virgil's Silenus is just scholarly window-dressing, interesting as a point of reference, perhaps, but relevant to Rubens's painting only in the many ways it differs in its depiction of Silenus.

One suspects that Professor Alpers knows this. In any event, the business about Virgil occupies a subsidiary role in her drama about the significance of *Drunken Silenus*. Her main point is that the painting shows that Rubens was "Protean in a gender sense" and that "Men undone by women and/or by drink, and the attendant cross-dressing, is an obsessive theme for Rubens."

As evidence for the alleged obsession with cross-dressing she cites a couple of pictures in which Rubens portrays men or boys dressed in women's clothes —*Achilles among the Daughters of Lycomedes*, for example. That picture refers to the episode in which Achilles' mother, knowing that her son is fated to die if he joins the expedition against Troy, disguises the nine-year-old boy in girls' clothes and sends him to live at the court of Lycomedes. In due course Achilles is discovered and recruited by Odysseus (it is this moment Rubens commemorates), but not before having an affair with and impregnating one of Lycomedes' daughters. Professor Alpers omits mentioning Achilles' heterosexual amorous adventure, doubtless because it would have taken a bit of spice out of her tale. But leave that to one side. More pressing is the presump-

tion behind Professor Alpers's claim. Let me formulate it as a question: Does the fact that someone portrays a male in female clothing (or vice-versa) imply that he has an obsession with cross-dressing? By this reasoning, cross-dressing would have to be accounted "an obsessive theme" for writers from the Greek mythologists to Shakespeare to P. G. Wodehouse. Was it? Or was it merely a hoary comic convention, a reliable plot-thickener, used by countless writers and artists? (It is amusing to contemplate what a bruiser like Achilles would have thought of Professor Alpers's suggestion.)

As with David Lubin on Sargent or Michael Fried on Courbet, one has to wonder how carefully Professor Alpers looks at the paintings she discusses. She says that the pattern of arms and legs in *Drunken Silenus* has "an effect not unlike the optical play in Duchamp's *Nude Descending a Staircase*." But does it? I mean, does it if the viewer is not himself drunk? Professor Alpers also suggests at one point that *Drunken Silenus* is a self-portrait. But if so, it is odd that it is a self-portrait that does not look at all like Rubens, assuming the many paintings he himself called self-portraits are to be trusted. Professor Alpers admits that "the kinship Rubens/Silenus takes us a bit further into Rubens's workings as an artist than he might consciously have been willing or even able to acknowledge." You said it, Professor! But could it—just possibly—be that Rubens would have been unwilling or even unable to acknowledge such a kinship because it didn't exist?

According to Professor Alpers,

What is disturbing about Rubens's Munich *Silenus* is that in it gender difference is unclear. Difference is de-

nied, or at least not marked: the body is not clearly male, nor is it female. In appearance and in behavior he exists, on Rubens's pictorial account, in a curious no man's and no woman's land, between or eliding genders. . . .

Why would a male painter in our tradition represent flesh in this manner? I think it has something to do with the problem of male generativity. How are men to be creative, to make pictures, for example, when giving birth is the prerogative of women?

She then proceeds with a little excursion about "the gaze," the "Lacanian notion of finding oneself through being looked at," and so on. But wait a moment. Is the "gender," i.e., the sex, of Silenus in any doubt? There have been such things as bearded ladies, but is Silenus one of them? Take a look at the illustration following page 84: is it true that the sex of Silenus "is denied, or at least not marked"? He seems obviously male to me. Forget the beard, the male pattern-baldness: just look at the musculature in his left shoulder. Pretty beefy, isn't it? And what about what Professor Alpers calls the "problem" of "male generativity"? *Is* it a problem? Possibly she thinks it is. But was it a "problem"—was it any sort of reality at all—for Rubens, than whom a more robust, fecund, and, yes, masculine painter is hard to imagine? The last time I checked, men were not giving birth to babies. Yet from the time of Lascaux on down they have been making pictures, blissfully unaware of the "problem" that Professor Alpers has thoughtfully formulated for them.

If Professor Alpers has trouble registering what is before her eyes, her imagination has no trouble populating works of art with all manner of surprising inci-

dent. Many people, looking at *Drunken Silenus*, might think it was an abundantly dramatic picture all on its own: the impressive figure of Silenus, pipe-playing satyrs, suckling panisci, jolly frolickers. There is also the attraction of Rubens's *painting*—the vibrantly rendered figures, foliage, and fruit. There is a lot to admire in *Drunken Silenus*. But few viewers, I think, would conclude, as does Professor Alpers, that the nursing satyress, in addition to dispensing nourishment, is "fondling (to placate him?) the penis" of one of her offspring. Even fewer, I'd wager, would believe that the picture was an allegory—if not a virtual depiction—of anal rape. But this is clearly what Professor Alpers thinks.

> The massive, naked figure looms, unsteadily, over us. But though he is pictorially dominant, Silenus is not dominating. Quite the contrary. He leans forward, head slumped in a stupor [but he's rather bright-eyed for being in a stupor, no?], his right arm extended only with assistance, while the left one is gripped by the hand of a black man who simultaneously pinches the ample flesh of Silenus's thigh and follows so close as to appear to be penetrating the huge body from behind.

Eh, what? In a footnote to this passage, Professor Alpers sadly admits that "buggery as such is only rarely depicted" in painting. But this fact does not prevent her from suggesting that Sir Peter Paul Rubens, decorous servant of crown and Church, has done so here. Professor Alpers basically argues that the black man standing behind Silenus grasps his thigh in order to facilitate sodomizing him. But Christopher Brown is surely right that

A more plausible explanation for what the black man is actually doing is that he is pinching Silenus's flesh to show to the amusement of his companions that Silenus is so drunk that he no longer has any feeling in his leg.

Brown's suggestion is more plausible in both intrinsic and extrinsic terms. His suggestion accords better with what Rubens has actually set down on the canvas, and it accords better with the sort of thing Rubens might have depicted given everything else we know about him, his work, and the conventions within which he worked.

Few people familiar with contemporary academic art history will really be shocked by Professor Alpers's psychodrama at Rubens's expense. Such "readings" are a dime a dozen today, too common to shock. But if such performances lack the ability to shock, they nevertheless retain the power to taint, to adulterate, to besmirch our experience of art. And when such interpretations are given the imprimatur of an academic eminence such as Svetlana Alpers, they obtain currency and the appearance of legitimacy that repetition inspires. It would be one thing if Svetlana Alpers were a fringe figure, promulgating her extravagant musings to an isolated coterie. But she is not a fringe figure. She is one of the most honored and influential practitioners of art history on the contemporary scene. As Hilton Kramer noted in an appropriately tart review of *The Making of Rubens*, Professor Alpers's book

is anything but marginal. It is, on the contrary, entirely representative of the intellectual catastrophe that has overtaken the writing of art history and art criticism in

this last decade of the twentieth century, not only at the higher altitudes of academic specialization and prestige but in the popularization of postmodern discourse that has now insinuated itself into the college classroom, the art museums, and the mainstream critical press.

Which is to say that books like *The Making of Rubens* do an enormous amount of damage by institutionalizing both an attack on art and an attitude toward cultural achievement. The attack proceeds partly by displacing art with politics of one stripe or another, partly by diffusing an atmosphere of smug trashiness. The attitude towards cultural achievement is one of barely concealed hostility. The result is a situation in which even vibrant and worldly artists like Rubens are made over in the sniggering, neurotic image of contemporary anti-humanistic pedantry.

Professor Alpers shows us one variety of academic feminism in action against art. Other varieties have different specific effects. Where Professor Alpers specializes in gender confusion, other feminists opt for more direct modes of assault. Nor does feminism have a monopoly on the means of artistic disestablishment. Similar strategies can be pursued in the name of other ideological campaigns. Just as Rubens can be conscripted in Svetlana Alpers's battle against traditional notions of sexual identity, so other artists—Winslow Homer, for example—can be implicated in the battle against racism. Winslow Homer? The battle against racism? Does that seem like an unlikely conjunction? Then you do not yet appreciate the brazenness with which the rape of the masters can proceed in the hands of a determined practitioner.

Chapter 5
Modernizing Winslow Homer

'Twere to consider too curiously, to consider so.
—Horatio, *Hamlet* v: i

I regret very much that I have painted a picture that requires any description.
—Winslow Homer, writing about *The Gulf Stream*

The quintessential Yankee

WINSLOW HOMER began *The Gulf Stream*—one of his best known oil paintings—in 1899 when he was in his early sixties and at the apex of his fame and powers. It had been a long time coming. Homer was nearly forty before he really emerged as a serious artist, fifty before his art had fully matured. The second of three sons, Homer had been born to a middle-class family in Boston in 1836. His father was a hardware merchant; his mother, with whom he was always very close, was an avid watercolorist hailing from Bucksport, Maine. ("He got it all from her," one cousin declared many years later.)

In 1842, Winslow's father moved the family into a commodious house adjacent to Harvard College. He hoped that proximity to so much learning would spark in his sons a passion to acquire some of it for themselves. It didn't work, at least not in Winslow's case. Books held no magic for him. Fishing and camping were more in his line—those things and drawing, another solitary activity he pursued devotedly from an early age.

By the time Winslow was eighteen, his father had suffered serious financial reverses (the California gold rush had tempted and almost ruined him), putting an end to talk of college. For a moment, it looked as though employment at a tony haberdashery might be in Winslow's future. But then his father arranged to apprentice him to a local lithographer. It was a productive if often unpleasant apprenticeship. Homer bristled at the routine. But he quickly gained competence and within a few years decided to strike out on his own. He began by supplying workmanlike illustrations for *Ballou's Pictorial Drawing Room Companion*. In 1857, the fledging *Harper's Weekly* took the first four drawings he sent them, beginning a long and profitable association. In 1861, when the Civil War erupted, *Harper's* sent Homer to the front with General McClellan's army as an artist-correspondent. Before the end of the war, he had become the magazine's most popular illustrator.

In 1867, Homer spent nearly a year in Paris. He worked hard, but it cannot be said that his art betrays much European influence. If he looked at the reigning French masters, his brush promptly forgot the fact. Homer first came into his own as a watercolorist. He

brought increasing delicacy and technical bravura to that uncompromising medium, even, on occasion, a shadow of existential recognition (*A Basket of Clams*, 1873) or wistful melancholy (*The New Novel*, 1878). In the early 1870s, he determined to leave magazine work behind. It was about this time that his art began to deepen beyond illustration. As late as 1875, however, Henry James could write, with characteristic Jamesian wonderment, that Homer "goes in . . . for perfect realism, and cares not a jot for such fantastic hair-splitting as the distinction between beauty and ugliness." Homer was "a genuine painter," James acknowledged. Yet

> he not only has no imagination, but he contrives to elevate his rather blighting negative into a blooming and honorable positive. He is almost barbarously simple, and, to our eye, he is horribly ugly; but there is nevertheless something one likes about him.

James didn't much care for Homer's portraits of "Yankee urchins" and "vacant lots of meadows." But he admired the blunt force of his tenacious literalism.

It is difficult to peek behind that literalism. The boy who liked fishing, camping, and drawing evolved into the man who devoted himself to those same activities. Nearly every biographer describes Homer as the quintessential taciturn Yankee: "practical, self-contained, sometimes brusque, always terse," as Philip Beam put it in *Winslow Homer at Prout's Neck* (1966). Until late in life, Homer was not unsocial, exactly. When he was living in New York, for example, he often attended the monthly meetings of that bastion of geniality, the Cen-

tury Association. But in many respects, Homer is to artists what Gertrude Stein's Oakland is to cities: there is no there there. "The problem with Homer," the critic Sarah Burns noted in her splendid essay "Modernizing Winslow Homer,"

> has always been understanding him. Every scholar and critic who tries to take him on comes up against the same wall of silence. Imagine the polar opposite of, say, Van Gogh, compulsively self-revelatory, and you have something close to Homer. He remains interesting because he discloses so little.

Homer had friends but no real intimates beyond the circle of his father, mother, and brother. He indulged in a few youthful flirtations: none was serious. He never married. He painted and apparently admired the English fisher girls at Tynemouth when he visited England, but his romance was more with the place than any person. He issued no proclamations, took up no causes. Most of his letters are a model of dullness. He traveled once to Chicago, twice to Europe, but spent most of his time somewhere on the Atlantic seaboard. In later life, he summered at Prout's Neck, near Portland, on the Maine coast and spent a good part of the winter in Florida or the Bahamas. He had, Clement Greenberg observed, "practically no life aside from his art," "no inner life worth mentioning."

You might think that the combination of Homer's reticence and the "perfect realism" of his work makes an unpromising field for the exercise of political correctness. After all, if the artist is mum, what can you do with straightforward paintings of the Maine or English

or Caribbean coastline? You might be surprised. As some recent interpretations of *The Gulf Stream* show, even Winslow Homer—dry, quiet, reclusive Winslow Homer—can be "modernized" and made to serve today's ideological agenda. All it takes is a suitably determined critic.

Sharks and other "outside matters"

Homer embarked on *The Gulf Stream* in the fall of 1899. He had made his second trip to Nassau that winter where he saw many boats plying the waters, their crews in search of fish or sponges or other trade. *The Gulf Stream* depicts a marine disaster. A small, dismasted sloop, its bowsprit blasted, its rudder lost, bobs helplessly in roiling, storm-tossed waters. Reclining on the rear deck is a shirtless, grim-faced Negro. Gripping a bit of line in his left hand, a tentacle of sugar cane in his right, the muscular young man has propped himself up on his left elbow against the gunwale and is scanning the waters off the boat's stern. Around the boat carouse a school of ferocious-looking sharks, biding their time until a sudden wave or gust of wind might deliver their prey to them. Off in the distance, a waterspout churns menacingly: has it already done its damage, or is it only now bearing down on the hapless vessel and its lone occupant?

Probably because of its dramatic subject, *The Gulf Stream* seems larger than its four-by-nearly-two-and-a-half-foot dimensions. (It is curious how memory enlarges some pictures. When I go to the Wallace Collection and see Poussin's *Dance to the Music of Time*, I

am always surprised by its smallness. I *know* it is small, but somehow it is always larger in my memory than it is on the wall.)

Scholars have proposed many artistic precursors for Homer's painting, including Delacroix's *Barque of Dante* (1822), Turner's *Slave Ship* (1840), Thomas Cole's *Voyage of Life* (1840), John Singleton Copley's *Watson and the Shark* (1778), and Théodore Géricault's *Raft of the Medusa* (1818–1819). But probably the most important inspiration was the artist's own experience. The coincidence that Homer's father had died in 1898 led one critic to reflect that *The Gulf Stream* "addresses the same pressing feelings of trouble and temptation, the approaching inevitability of life's end, and the necessity of faith that Cole expressed in the language of allegory." Perhaps. But the sea in its majesty, its fury, its mystery, and its tranquillity had long been at the center of Homer's work. He painted marine scenes from Gloucester, Massachusetts, to Tynemouth and from Prout's Neck to Cuba and the Bahamas. Homer claimed to have crossed the Gulf Stream ten times. He commented on the many derelict boats he saw (the dangerous currents there make patches of the area a graveyard for small boats). In Homer's own work, the germ of *The Gulf Stream* can be traced back to 1885 and *The Derelict*, a small watercolor of a smashed boat run aground and surrounded by sharks—nearly the same family he reprised in *The Gulf Stream*.

Homer painted his share of calm and sunny pictures, but he is more famous for storm scenes and tempests. There was, as Clement Greenberg observed, "a streak in him of the popular romanticism of the violent and

melodramatic." *The Gulf Stream* typifies the genre: "a hurricane *and* sharks *and* a waterspout," as the Homer scholar Gordon Hendricks noted. Yet one of the triumphs of the picture is the contrast Homer achieved between the terrifying subject matter and the seductive opulence of the ocean: a luscious symphony of blues and whites and greens. He apparently took great pains with the water. Homer hadn't quite finished the picture when Harrison Morris, director of the Pennsylvania Academy, wrote asking if he could include it in an exhibition in January 1900. Morris could not, he wrote, open "the greatest American art exhibition" without an example from "the greatest American artist." Homer sent *The Gulf Stream* along unfinished, worked on it again when the exhibition closed, and then sent it to Knoedler, his dealer in New York.

The Gulf Stream made the rounds for several years before the Metropolitan Museum of Art in New York bought the picture in 1906. A critic for *The New York Times* applauded the purchase, describing *The Gulf Stream* as a "powerful and superb picture" that showed "the cruelty of the elements and the elemental creatures of the sea." Others were less impressed. Trustees of the Worcester Art Museum had considered buying the picture by the famous artist but decided its subject was too depressing. One critic dismissed it as a "unique burlesque" and proposed renaming it *Smiling Sharks*.

Some prospective clients pressed Knoedler's for an explanation of the painting: What did it mean? What was the fate of the unfortunate young man? Knoedler's forwarded the request to Homer and received this curt reply in February 1902:

You ask me for a full description of my Picture of the "Gulf Stream"—I regret very much that I have painted a picture that requires any description—The subject of this picture is comprised in *its title* . . . I have crossed the Gulf Stream *ten* times & I should know something about it. The boat & shark are outside matters of little consequence. *They have been blown out to sea* by a *hurricane.* You can tell these ladies that the unfortunate negro who is now so dazed & parboiled, will be rescued & returned to his friends and home, & ever after live happily—

Yrs Respy W. Homer

The important point lurking behind Homer's impatient sarcasm was aptly articulated by a critic for *The Evening Post. The Gulf Stream* was "a great dramatic picture," he said, not because of its dramatic subject but

partly because the horror is suggested without a trace of sentimentality and partly because every object in the picture receives a sort of over-all emphasis that shows no favor to the dramatic passages. As a result the story never outweighs the artistic interest.

"The story never outweighs the artistic interest": that was precisely what Homer was getting at when he insisted that "the boat & shark are outside matters of little consequence." I wonder what Homer would have had to say about Nicolai Cikovsky's suggestion that *The Gulf Stream* evinces "an almost Schopenhauerian philosophical preference"? Well, he would probably have thought better of that high-toned suggestion than

of Cikovsky's speculation that "The sharks in *The Gulf Stream* . . . , encircling the helpless boat with sinuous seductiveness, can be read as castrating temptresses, their mouths particularly resembling the *vagina dentata*, the toothed sexual organ that so forcefully expressed the male fear of female aggression." Turn to the plate of *The Gulf Stream*. How many "castrating temptresses" do you see there? Er, none? (What is it about castration and art critics, anyway?)

According to Cikovsky, "Homer's fear of women was so strong . . . that he could not fully repress it." As evidence, he reprints a letter in which Homer complains to his dealer about an importunate female journalist. In the course of the letter, Homer sketched a pistol, commenting below it that "*The ladies deserve all they ask for.*" For Cikovsky, this is proof positive that Homer, like Picasso, suffered from a terrible case of gynophobia. Whoa! Picasso? Winslow Homer and Picasso? Gee. As Sarah Burns observes,

> It is almost too easy to make Picasso's case—but the evidence for Homer is so slim that it is difficult even to entertain. Picasso's oeuvre, after all, exhibits scores of vaginas, literal and metaphorical, toothed or otherwise, and his love life was an open book of stormy, pathologically driven, well-documented relationships with a long series of women. With Homer, there is almost nothing to go on—only that scribbled pistol (the smoking sexual gun, presumably)—and whatever his relationships, they have never been discovered or revealed.

Nikolai Cikovsky is an expert on Homer's work. But his

effort to modernize Homer, to make him an appealing subject for contemporary critical inquiry, has led him into preposterous fantasy. Homer painted those sharks not because he was repressed or feared women but because when he visited the Gulf Stream he saw sharks swimming around derelict boats and he thought it would make for a dramatic motif. It's that simple.

Homer and the race card

It goes without saying that the sharks are not the only objects of critical fantasy. There is also the boat's unfortunate passenger. Who knows what would have happened had he been white? But Homer painted a black man, and that fact has opened the gates to all sorts of politically correct speculation.

The project of enlisting Homer as an activist for the cause of Black Americans seems to have begun in the 1980s with Peter Wood's essay "Waiting in Limbo: A Reconsideration of Winslow Homer's *The Gulf Stream*." Impatient with the traditional emphasis on the painting's "stylistic attributes"—the "preoccupation with pigments, patterns, and brushstrokes"—Wood endeavors to reveal *The Gulf Stream*'s "complex and paradoxical meaning in the Afro-American experience." Wood's essay is largely given over to little sermons about the evils of racism and the slave trade. But he also tries to conscript Homer as a prop for his display of self-satisfied indignation. "Did Homer give a damn about this Negro," Professor Wood asks, "or about blacks generally?" Er, not so you'd notice, Professor. He wasn't hostile. He didn't want to bring

back slavery or anything like that. He probably had friendly thoughts about the natives he watched diving for sponges in the Caribbean. But was he a crusader for the down-trodden? Even Professor Wood is driven back to speculating about his "subconscious sensitivity" to blacks, women, etc. It was so subconscious that it might as well not exist.

Professor Wood's essay marked an unfortunate turning point. Henceforth Homer became a happy hunting ground for academics interested more in racial politics than art. But in retrospect, when it comes to the issue of race in Homer's painting, we see that Professor Wood's effort was merely a preliminary expectoration. For the main event, one has to turn to "Blacks in Shark-Infested Waters: Visual Encodings of Racism in Copley and Homer," an immensely influential essay published in 1989 by Albert Boime, a professor of art history at the University of California at Los Angeles and author of more than a dozen books and scores of articles on art historical topics.

Professor Boime is keen to show how Homer and Copley—"North American artists from privileged white middle-class backgrounds"—"transmitted the attitudes of their peers toward blacks." Exactly how "privileged" Homer's background was is open to dispute; but since no self-respecting essay in the humanities these days can proceed without deploying the word "privilege" in a blithely contemptuous manner, we may leave that to one side. As with Professor Wood, Professor Boime devotes most of his energy to declaring his own opposition to racism. He involves Homer in this task by claiming that *The Gulf Stream* is "an allegory of the black man's victimization at the end

of the nineteenth century." Evidence? Well, he points out that in the year Homer painted *The Gulf Stream* eighty-seven blacks were lynched in America. Four years earlier, in 1895, Homer went to collect a medal at the Cotton States International Exhibition. Professor Boime reproduces part of a speech that Booker T. Washington delivered at the Exhibition and tells us that "Homer would have carefully followed events [there], . . . including Washington's highly publicized address." But he supplies no evidence of Homer's interest in this issue, and I have not been able to find any.

Following some hints from Professor Wood, Professor Boime makes a great deal of the stalks of sugar cane that sprawl over the deck of the sloop in *The Gulf Stream*. "Here," he says, "Homer reveals his understanding of the relationship of economics to the plight of blacks and their survival."

> Homer's conspicuous representation of the stalks, totally out of proportion to the boat and its lone passenger, assumes a symbolic and metonymic connotation in its intimate relationship to the history of slavery in the West Indies. . . . But when Homer painted his picture, this allusion would have taken on yet another level of meaning: America's imperialist ambitions—culminating in the Spanish-American War of 1898—devolved on the Hawaiian Islands, the Philippines, Cuba, and Puerto Rico, all of them rich sugar-producing territories and all of them worked by blacks soon to suffer the discriminatory policies of a racist society.

But isn't it more likely that Homer decided to include those stalks of sugar cane because he saw many boats

transporting the stuff when he visited the Caribbean? Far from assuming a "symbolic and metonymic connotation" to anything, far from being a reflection of "America's imperialist ambitions," isn't it more likely that those meticulously rendered tendrils of sugar cane are just another example of what Henry James called Homer's "perfect realism"?

Citing Homer's impatient letter explaining that "The subject of this picture is comprised in *its title*," Professor Boime says that

> Homer's ironic tone carries with it the masculinized aura of the Victorian male who admired risk-taking situations remote from the realm of "ladies," but it also signifies the opposite of what he stated [How does Professor Boime know this?]. . . . Homer's black man is both hero and victim, collapsing the old categories of triangular formalism into a powerfully condensed metaphor of implicit power blocked.

Maybe. Or maybe the whole idea of "collapsing the old categories of triangular formalism" was invented lock, stock, and barrel by Professor Boime, who is more concerned to declare his correct attitudes about race than to appreciate Homer's painting on its own terms.

PROFESSOR BOIME'S ESSAY has two objects: the first is to declare his own, and by implication his readers', bona fides on the issue of race. His essay, full of stories about the depravity of nineteenth-century white racists in America, is an excuse to indulge in feelings of self-righteous virtue: "Thank God we are not such be-

nighted souls ourselves!" The second object is to enlist
Winslow Homer in this orgy of self-righteousness by
making him over into a "progressive" artist mightily
concerned with the plight of Black Americans. The
problem with this edifying interpretation, as Sarah
Burns observes, is that—on this issue as on so much
else—"It is quite difficult . . . to pin him down."
Homer did paint some pictures that can be taken as
sympathizing with the plight of Black Americans. But
he painted others that evince "caustic irony" about
"the hollowness of the 'freedoms' won by former
slaves." Homer called his paintings of Black minstrels
his "darkey pictures." Is that "progressive"? No. Does
it make him racist? Again the answer is No. Homer
was an artist, a painter, and one, moreover, of unusual
reticence. The effort to import psycho-sexual themes
into his pictures is just silly. Similarly, whatever his
political passions, if he had any, they simply did not
intrude into his art. *The Gulf Stream* is about an im-
agined scene on the Gulf Stream. As Henry James ob-
served, "Mr. Homer's pictures . . . imply no ex-
planatory sonnets." To pretend otherwise is to betray
historical reality; it is also to betray Homer for the sake
of a political agenda.

Chapter 6
Fetishizing Gauguin

Diseases desperate grown
By desperate appliance are relieved,
Or not at all.
—Claudius, *Hamlet* IV: III

The artificial savage

IF PAUL GAUGUIN (1848–1903) did not exist, it
would have been necessary to invent him. A more
perfect embodiment of the Bohemian Romantic Artist is
difficult to imagine. Gauguin's pedigree as a B.R.A. is
perfect for the role. Born in Paris (the epicenter of artis-
tic innovation in the mid-nineteenth century), he was
bundled off to Peru (certified exotic venue) as a toddler.
His father, a journalist, died en route (necessary element
of familial tragedy). His mother was partly of Peruvian
descent, a fact that allowed Gauguin to claim proudly in
1889 that he had "Inca blood" (requisite ethnic swar-
thiness): "it's reflected in everything I do," he said. For
four years, Gauguin lived with his mother and older
sister in Lima before the family returned to France in

1855. At seventeen, Gauguin joined the merchant marine (Romantic wanderlust), courtesy of which he sailed twice to Brazil and once around the world.

In 1873, Gauguin married a Danish woman called Mette Gad, by whom he had five children. He worked for some years as a stockbroker (bourgeois phase) and began painting seriously in the 1870s, first exhibiting in the Salon in 1876. By the late 1880s, he had chucked wife, children, and career for the sake of his capital-A Art. Mette remained a loyal broker of his work back in Copenhagen (longsuffering wife motif), though she later admitted that her husband had been "*mal élevé*," "badly brought up." (Gauguin's mother might have agreed. In 1865, she drew up a will in the course of which she suggested that her son "get on with his career, since he has made himself so unliked by all my friends that he will one day find himself alone.")

After leaving Mette, Gauguin cavorted hither and thither in gradually increasing poverty and alienation, contracting syphilis (Romantic disease par excellence) along the way. He befriended and regularly quarreled with (fiery artistic temper) some of the most important writers and artists of the period, including Pissarro, van Gogh, Degas, and Mallarmé. By the late 1880s, Gauguin had concluded that his unhappiness was due to civilization itself and accordingly began extolling the primitive, the exotic, the "savage." "I try to confront rotten civilization with something more natural, based on savagery," he proclaimed in 1889. As part of his retreat from the rottenness of civilization, Gauguin decided to remove himself to Tahiti (inexpensive and exotic locale), where in 1897 he attempted suicide (Romantic despair), painted his most famous pictures

(flowering of genius in the tropics, far from bourgeois civilization), and disported himself with some of the local girls (required element of sexual adventure). Gauguin made two long trips to Tahiti. The first, officially on assignment for the French Ministry of Public Education and the Fine Arts to "study and ultimately to paint the customs and landscapes of Tahiti," was from 1891 to the beginning of 1893, the second from 1895 to his death in 1903. Although he never admitted Gauguin was his model, Somerset Maugham clearly had him in mind for the figure of Charles Strickland, the "strange, tortured, and complex" genius he portrayed in *The Moon and Sixpence* (1919).

Gauguin's favorite place to paint was . . . elsewhere—any spot that was 1) inexpensive and 2) far removed from the familiarity of his everyday world. He tried Brittany. He tried Panama (where he worked briefly on the canal). He tried Arles with van Gogh. Before quarreling irreparably, they wrote to their friend Emile Bernard to announce their dream of "a new art [that] will have the tropics for a home." "The tropics" —the phrase named a state of mind as much as a geographical locus—loomed large in Gauguin's imagination. Pierre Loti's 1880 bestselling fantasy novel *The Marriage of Loti*, which is set in Tahiti and tells the story of a love affair between an alienated French naval officer and a young Tahitian girl, made a deep impression on Gauguin. So did the Universal Exhibition in Paris in 1889, which featured not only the Eiffel Tower and the Gallery of Machines, but also a section devoted to Tahiti in the Colonial Exhibition. In an interview shortly before his departure for Tahiti in 1891, Gauguin explained that

I'm leaving so that I can be at peace and can rid myself of civilization's influence. I want to create only simple art. To do that, I need to immerse myself in virgin nature, see only savages, live their life, with no other care than to portray, as would a child, the concepts in my brain using only primitive artistic materials, the only kind that are good and true.

No wonder Gauguin enjoyed a new burst of popularity in the 1960s.

In the event, Gauguin vacillated wildly in his response to Tahiti. In his memoir/notebook *Noa Noa*, a collaboration with the poet Charles Morice written in the early 1890s but not published until 1901, he waxed ecstatic: "Tahitian *noa noa* [i.e., "fragrance"] pervades the whole of me. I am no longer conscious of the days and of the hours, of Evil and of Good—all is beautiful—all is well." But *Noa Noa*, which was intended to explain Gauguin's latest paintings to the French public, was at least partly a public-relations device, which is to say a sales pitch. In fact—surprise, surprise—Tahiti was not unremitting bliss. Although Gauguin was soon writing home to assure everyone that "My life is now that of a savage," he also had to acknowledge sadly that "Oceania [has been] swamped by civilization."

It is easy to make fun of Gauguin's adolescent idealization of the exotic. As Clement Greenberg observed, Gauguin

did not understand that his dissatisfaction with Europe could not be relieved by transporting himself elsewhere in space and culture, that he remained in the nineteenth

century wherever he went. Instead of criticizing and revealing the world of which he was an ineluctable part, . . . Gauguin tried to find an immediate alternative. He was misled, as many a later artist has been, into thinking that certain resemblances between his own and primitive art meant an affinity of intention and consciousness. . . . [H]e engaged in a forced and feverish effort to realize that insubstantial affinity. The result is something partly artificial, something that lacks reality, however much of genius it shows.

Camille Pissarro, who had been an important mentor to Gauguin in the 1870s, regarded his former disciple's increasing waywardness with dismay. When Gauguin told him that young painters would henceforth need to "replenish themselves" at "remote and savage sources," Pissarro confided his feelings in a letter to his son Lucien:

> I told him that this did not belong to him, and he was a civilized man and hence it was his function to show us harmonious things. . . . Gauguin is certainly not without talent, but how difficult it is for him to find his own way. He is always poaching on someone's ground; now he is pillaging the savages of Oceania.

In fact, Gauguin was one of those carelessly brutal characters who strewed human wreckage in his path. What makes him interesting, however, is not his human, all-too-human flaws: his narcissism, his utopianism, or his fondness for women who were (as he put it in his Journal) "fat, vicious, and stupid with nothing spiritual." On the contrary, what makes

Gauguin of interest was his artistic achievement. Gauguin's art was undoubtedly fed by his life—the impossible egotism, rage, and yearning. But there are plenty of impossible egotists abroad. Not many manage to produce memorable works of art.

Dreaming before nature

Gauguin occupies an important transitional position in the development of modern art. In the late 1870s, under the influence of Pissarro, he was firmly in the camp of Impressionism. But by the mid-1880s, he had moved away from Impressionism toward the more abstract and distilled creations of what he called "Synthetist" or Symbolist art. Where Impressionism emphasized fidelity to the visual image, Synthesist art extolled fidelity to feeling or mood. This was an art that sought, as the art historian Robert Goldwater put it, not to capture any definite reality but rather to conjure "suggestion through infinite nuance." The poet Stéphane Mallarmé provided, *avant la lettre*, a motto for the movement when, in 1864, he admonished artists "*Peindre, non la chose, l'effet qu'elle produit*": "Paint not the thing, but the effect which it produces." In a letter to a friend, Gauguin generalized the advice: "don't copy nature too much. Art is an abstraction, derive this abstraction from nature while dreaming before it, and think more of the creation which will result" than of the model.

As his painting developed, Gauguin more and more abandoned the visual impression for the emotional correlative it inspired. In *Diverses Choses*, notes jotted

down in Tahiti in 1896–97, Gauguin looked back critically at Impressionism and spoke of its "shackles of verisimilitude" ("shackles" being a negative epithet that one frequently encounters in Gauguin's writings). He complained above all that the Impressionists "heed only the eye and neglect the mysterious centers of thought." The effort to adumbrate the texture of that mystery—to reveal it *as* an irreducible mystery—became the overriding goal of Gauguin's art. He later claimed that "the essence of a work, insubstantial and of a higher order, lies precisely in what is not expressed."

That quasi-mystical ambition required, Gauguin believed, a radical break with the artistic practice of the past. "More than ever," Gauguin wrote in 1885, "I am convinced that there is no such thing as exaggeration in art. And I even believe that there is salvation only in extremes."

Gauguin pursued his strategy of extremity partly through exotic subjects, partly through a deliberately shocking use of color—wild (as it seemed then) contrasts of acid hues against dry, nearly monochromatic backdrops—and partly through a drastic simplification or distillation of form and incident. The result—when everything worked—was an art of eldritch power and suggestiveness. If, as Greenberg noted, there was a certain technical clumsiness about Gauguin's painting ("frankly, Gauguin does not draw well enough"), there was nevertheless something peculiarly, indefinably memorable about his strongest work: an oddly hieroglyphic quality, as if his paintings were stills from some ritual drama of unknown liturgy.

To be sure, there is a windy pretentiousness about

Gauguin: it takes a strong man, after all, to title a painting *D'où venons-nous? Que sommes-nous? Où allons-nous?* (*Where Do We Come From? What Are We? Where Are We Going?* [1897–1898]). But in Gauguin's best work, the compensation for the pretension is unusual aesthetic potency. The sprawling (five-by-twelve-foot) *D'où venons-nous?*, one of Gauguin's masterpieces, is a prime example.

Another is the more compact *Manao tupapau (The Spirit of the Dead Watching)* (1892). As the Gauguin scholar Charles F. Stuckey noted, this twenty-eight-and-a-half-inch-by-nearly-thirty-six-inch canvas is "a brilliant resumé of all the formal and theoretical progress [Gauguin] had made since his arrival in the South Seas."

Let's take a look at the plate illustrating this picture to get our bearings. What do we see? *Manao tupapau* portrays Gauguin's first Tahitian mistress, Teha'amana, whom he met and "married" when she was thirteen. Tehura (as Gauguin called the girl) is shown lying naked, belly down, on a bed, her rich brown body sumptuous on the cool yellow-white bedclothes. She lies with her ankles crossed at the lower right corner of the bed. Her arms are crooked and tucked in close to her upper body, her hands open with palms down on a pillow that spills off the right edge of the picture. By her left arm the picture is punctuated by a bright pink patterned cloth. Her head is turned towards the viewer, her brow glows in a patch of light. Tehura's eyes are open, but she wears an enigmatic, distracted expression: simultaneously registering and looking past the viewer. In the lower quarter of the picture, beneath the floating white bedclothes, is draped a deep blue *pareu*

decorated with a large brilliant yellow floral motif. The upper half of the picture is a scumbled violet expanse from which fragments of decoration—brown tendrils, green leaves, white blossoms—emerge. Standing totem-like in the upper left corner is the *tupapau*, the black-hooded "spirit of the dead" for which the painting is named.

As several early observers noted, *Manao tupapau* is in part an homage to *Olympia* (1863), Edouard Manet's infamous painting of a Parisian courtesan. Gauguin had made a meticulous copy of the work shortly before his first trip to Tahiti. And *Manao tupapau*, in its placement of a reclining female nude and the attending figure, clearly echoes Manet's painting. But if *Manao tupapau* is, as the critic Thadée Natanson put it, "the Olympia of Tahiti," it nonetheless occupies a very different emotional register from Manet's painting. *Olympia* is a frank sexual provocation. *Manao tupapau* is instinct with mystery but not, curiously, with eroticism. The *scene*—naked Tahitian girl, welcoming bed—is full of erotic *possibilities*, but it was part of Gauguin's genius here to populate the canvas with a very different species of feeling.

The basic feeling, as Gauguin himself noted in several letters, is fear: the sudden fright of a young woman who wakes in the dark and senses the presence of menacing spirits. In *Noa Noa*, Gauguin recalled the genesis of the picture: Coming home at one in the morning after his carriage had broken down, he found the room in darkness.

Tehura lay motionless, naked, belly down on the bed: she stared up at me, her eyes wide with fear, and she

seemed not to know who I was. For a moment I too felt a strange uncertainty. Tehura's dread was contagious; it seemed to me that a phosphorescent light poured from her staring eyes. . . . Perhaps she had taken me, with my anguished face, for one of those legendary demons or specters, the *tupapaus* that filled the sleepless nights of her people.

Gauguin distinguished between what he called "the musical part" of the picture—"undulating horizontal lines, harmonies in orange and blue linked by yellows and violets"—and the "literary part"—"the spirit of a living girl linked with the spirit of Death. Night and day." Writing in a notebook he was preparing for his daughter, Gauguin recalled that he had been

> attracted by a form and a movement, and painted them, with no other intention than to do a nude. In this particular state, the study is a little indecent. But I want to do a chaste picture, and above all render the native mentality and traditional character. . . . As soon as this idea of a *tupapau* has occurred to me, I concentrate on it and make it the theme of my picture. The nude thus becomes subordinate.

The extraordinary thing about *Manao tupapau* is the way in which Gauguin managed to assimilate his exotic subject matter to the overriding aesthetic concerns that motivated the painting. The nude, as Gauguin observed, is subordinate to a drama of form and color, a painterly conjuring of place, character, and emotion: the "mysterious centers of thought" he wanted his art to reveal.

Avant-garde fetishization

That, anyway, is how Gauguin understood the painting. For the feminist art historian Griselda Pollock, however, *Manao tupapau* is less a painting than an indictment. In *Avant-Garde Gambits: Gender and the Color of Art History*, Professor Pollock draws up a detailed brief against Gauguin, using *Manao tupapau* as one of her chief pieces of evidence. According to Professor Pollock, the painting (like Gauguin himself) is racist. It is sexist. It is colonialist. It is capitalist. She refers early and often to Gauguin's "underlying guilt" and "spurious" efforts to explain the painting in aesthetic terms. It's not just Gauguin whom Professor Pollock objects to: it is the whole "masculinist" establishment of Western art. *Olympia*, she tells us, "is a representation of the spaces of bourgeois masculinity where working women's bodies are bought and sold. . . . The painting signifies commodity, capital's penetration of bodies and desires." And to think that until Professor Pollock came along we all regarded *Olympia* as a modern masterpiece! Question: there are many, many pictures of naked women in the world. Some of them are pictures of prostitutes or courtesans. What distinguishes Manet's painting from your run-of-the-mill nude? If Professor Pollock were right, the answer would be "Nothing important: what matters is the political subtext which I will be happy to supply you with."

Professor Pollock, who teaches at the University of Leeds, where she is also director of the Center for Cultural Studies, the Center for Jewish Studies, and Graduate Studies and Research in Feminist Theory, History

and Art, approaches art as a battleground. Paintings are not works of art but summaries of political rectitude or malfeasance. By the same token, artists are not the fabricators of paintings, sculptures, and so on, but moral warriors on the side of good or evil.

Professor Pollock begins her book by confiding that she was born in South Africa and hence has first-hand experience of "the distorting lens of apartheid." Her implication is that she also has a special sensitivity to the enormity of racism and, by extension, other items in the *index prohibitorum* of political correctness— Eurocentricism for example: "The reality is," Professor Pollock writes, "that anything the Europeans have touched is contaminated by their money and disciplined by their gaze, imprinted with their power, and shaped by their desire." She early on acquaints us with her "political and personal need to confront the issues of racism in art history." We, too, are urged to join the PC brigade. "In a post-colonial era," Professor Pollock warns, "no Westerner can be complacent about the late nineteenth-century conjunction of aesthetics, sexuality, and colonialism."

In fact, such "complacency" is not only possible but positively desirable for anyone interested in art as distinct from social-moral sermonizing. For Professor Pollock, however, the chief questions are the political questions. "How," she asks, "does a European woman position herself" in relation to the "colonialist" and "exploitative" history of modernism? Must she adopt the "professional transvestism normally required of women scholars and either masochistically identify with the image of [her] own objectification . . . or displace [her] interest onto formal concerns?" Note well:

according to Professor Pollock a traditional scholarly approach to art is a form of masochistic "transvestism," while being absorbed by formal issues—i.e., *aesthetic* issues—is a questionable displacement of more pressing concerns.

If Professor Pollock is right, Gauguin is culpable on several counts. For one thing, he was a careerist. He approached his art with "calculated career strategies" and sought to advance himself by "intervening in the interrelated spaces of representation, publicity, professional competition and critical recognition." *Manao tupapau*, she tells us, was "Gauguin's big stake in avant-garde game-play in relation to what was then still the key subject of Western painting, the female nude."

But ambition was only one of Gauguin's sins. Even more horrible was his attitude toward women, Tahitian natives, sexual identity, and race. Drawing on such figures as Franz Fanon, whose *Wretched of the Earth* (1961) is a fashionable document in the library of pro-terrorist literature, and Jacques Lacan, whose radical Freudianism has been a godsend to sex-obsessed obscurantists everywhere, Professor Pollock charges that

[i]n Gauguin's work as it circulated in Paris, the body of Teha'amana is a fetish doubly configured through the overlapping psychic structures of sexual and racial difference. In art, as the nude, the female body is refashioned fetishistically, in order to signify the psychic lack within bourgeois masculinity which is projected out onto the image of "woman." The culturally feminized and racially othered body also carries

the projected burden of the cultural lack—the *ennui*—experienced by some of the Western bourgeoisie in the face of capitalism's modernity.

Professor Pollock criticizes Gauguin (and others) for creating "an imaginary world named 'the Tropics.'" But she has populated a far more tenuous venue with her fervid imaginings.

> Teha'amana's presence is erased as this painted brown body becomes a sign not of a particular Oceanic woman, but of European man, a sign of art, itself a fetishistic structure which defends us against the complexities of what Marx called real relations. Behind the label "Olympia," by the imposition of that conversation between two avant-garde moments, Gauguin achieved his own precarious inscription into the avant-garde's narrative and canon. All these compound the excision from history of Teha'amana and whatever she might signify. What remains is the avant-garde fetishization of its own processes and procedures; not a sign of cultural specificity but merely the mark of difference from "the privileged male of the white race," to use Gayatri Spivak's comprehensive term.

Actually, what remains, though you wouldn't know from Professor Pollock's book (and you certainly wouldn't know it from the Derrida groupie Gayatri Spivak) is Gauguin's painting: the haunting image that he painted on a piece of burlap.

Like Svetlana Alpers, like Michael Fried, like all of the art historians featured in this book, Griselda Pollock approaches her subject with a large bibliography

and an impressive cache of expert knowledge. This indeed was one reason that *Avant-Garde Gambits* began life as the the twentieth-fourth Walter Neurath Memorial Lecture in 1992. That distinguished lectureship has included such art-historical eminences as Lawrence Gowing, John Pope-Hennessey, Kenneth Clark, and John Elderfield. In other words, what we are dealing with is not a fringe phenomenon but rather an example of what the academic art-historical establishment regards as deserving its highest plaudits. What previous Neurath lecturers such as John Pope-Hennessey or Kenneth Clark would have thought of Professor Pollock's manifesto is partly amusing, partly horrifying to contemplate.

ONE NEED NOT be a particular fan of Gauguin's work or his tropical fantasies to see that Griselda Pollock has left his art far behind in her effort to disseminate (if I may use such a "masculinist" term) her politically correct feminist-multicultural gospel. But poor Griselda Pollock. She did her best to show that Gauguin's writings exposed "the structure of European masculine heterosexuality, its eroticism dependent on opposing pairs, such as the licit/illicit, the chaste/indecent, the sexual/aggressive, the anthropological/voyeuristic." She was careful to castigate Gauguin's reference to "native mentality" as "benighted." She was always on the lookout for "racist implications" in his paintings. But political fashions change rapidly in the overgrown tropics of academia. In 1992, Griselda Pollock was au courant, attractively transgressive, suitably cutting-edge. But by 1997, she was old hat. Thus Stephen F. Eisenman in *Gauguin's Skirt* argues that although her

discussion of Gauguin is "in many ways plausible," it is nonetheless "as misleading as the earlier benighted formulations" because it reiterates "mechanical formulations . . . concerning the 'Occident' and 'Orient'" and fails to "make use of the more complex formulations of . . . post-colonial scholars . . . such as Gayatri Spivak and Homi K. Bhabha."

Oh dear, Oh dear . . . Griselda Pollock did her best. She made admiring references to Gayatri Spivak. Did she somehow leave Homi K. Bhabha out of account? There are so many post-colonialists, so little time. How could she have known she would be outflanked on the Left by someone who actually endeavored to rehabilitate Paul Gauguin: not, of course, as an artist —who cares about *that*?—but as a man of ambiguous sexuality whose painting *Manao tupapau* "is an image of liminal sexuality in colonial Tahiti"? Professor Pollock was so busy running down Gauguin for being a sexist pig that she neglected the possibility that (as Professor Eisenman assures us) Gauguin embraced "savage androgyny" and hence "identified with" his mistress "in previously unsuspected ways." Among other things, Professor Eisenman illustrates how a one-upping radical fashion operates in art history departments (and elsewhere) in today's academy. Yesterday's dreary verities—remember the banner of race, class, gender?—are trumped by ever more sublime sectarian causes: post-colonialism, "liminal sexuality," etc., etc. The fashionable radicalism that fuels so much contemporary art criticism is—like fashionable radicalisms in other areas of life—a creature that grows fat by devouring its young. It was ever thus.

Professor Eisenman's discussion of Gauguin as a

denizen of the "non-dimorphic sexual world" of Paris and Tahiti and whose dress was "a form of drag" rivals in hilarity Professor Lubin on Sargent and the word "boîte" (see above, pages 90ff). Gauguin the artist is nowhere to be seen. Professor Pollock dispensed with art for the sake of a feminist diatribe, Professor Eisenman for the sake of a polymorphously perverse fantasy. Both are preposterous. If it weren't for their influence, their writings would be merely laughable. As it is, they are wholly repellent.

Chapter 7
Deconcealing van Gogh

Words, words, words.
—Hamlet to Polonius, *Hamlet* 11: ii

Was van Gogh a metaphysician?

THE JURY is still out in the contest to determine the most wildly over-interpreted painting in the history of the universe. I would not presume to second-guess the judges—the contestants are many, the competition fierce. But I would like to put in a word for my own candidate, *A Pair of Shoes* (1886) by Vincent van Gogh (1853–1890).

This humble oil, some fifteen-by-eighteen inches, was one of eight pictures of shoes that van Gogh painted when he was in Paris from 1886 to 1888. It was an important time for van Gogh. In the space of two years he painted almost 230 paintings—more, according to the van Gogh scholars Ingo Walther and Rainer Metzger, "than in any other comparable period of his life." That extraordinary burst of productivity, which saw van Gogh experimenting with many different

styles and motifs, brought him to the threshold of his late style with its startling color contrasts and magnified, pointillist-inspired impasto.

I am not sure what it is about van Gogh that inspires critical hyperventilation. Perhaps it is his position as the archetypal Tragic Artist—the lonely, misunderstood genius who never sold a single painting, maimed himself after quarreling with Gauguin, and then ended his life a suicide at the age of thirty-seven.

When I was in high school, I attended a lecture at a local university at which an eminent Heidegger scholar offered an interpretation of van Gogh's famous painting of his bedroom in Arles (1889). I forget the details of the presentation, alas, but I do recall that there was good deal about van Gogh's intuitively grasping the principles of quantum mechanics and non-Euclidean geometry. All those apparent distortions of perspective were not really distortions, evidence of eye trouble, or tokens of madness, you see. Properly understood, they showed that Vincent saw deeper into the structure of reality than you or I do. I was mightily impressed at the time.

In retrospect, it seems particularly appropriate that the van-Gogh-as-quantum-physicist chap was an expert on Heidegger. For it was Martin Heidegger who first put van Gogh's shoes into critical orbit. In "The Origin of the Work of Art," an essay that began life in 1935 as a lecture, Heidegger seized upon that painting by van Gogh to illustrate his thesis about the way that "the art work opens up in its own way the Being of beings."

This opening up, i.e., this deconcealing, i.e., the truth

of being happens in the work. In the art work, the truth of what is has set itself to work. Art is truth setting itself to work. What is truth itself, that it sometimes comes to pass as art? What is this setting-itself-to-work?

Pretty impressive, eh? You can see why this essay was such an immense hit. How amazing to think that a work of art—a painting of some old shoes, say—is not just a painting of some old shoes but is "truth setting itself to work."

Of course, you need to redefine what "truth" means for this statement to have even the semblance of plausibility, but using words in novel, unorthodox ways is what we pay German metaphysicians for. If asked, you would probably define truth along the lines of the traditional formula: truth is the correspondence of thought with its object. But how much more fun if you say, with Heidegger, that truth is "undisclosedness." It works even better if you can insert, as he does, a Greek word:* truth is ἀλήθεια. Between us, that word really just means "truth"—"opp.," the dictionary tells us, to "*lie* or *mere appearance*." But if you are Heidegger, you make sure to translate it as "undisclosedness," explaining that the normal translation— he writes "*trans*lation"—is a Roman distortion or

* It is worth bearing in mind, however, that Heidegger wasn't averse to associating truth with some good old German words: *Blut und Boden*, for example: "blood and earth." Heidegger joined the Nazi party in 1933 and was, for about ten months, rector of Freiburg University. The extent to which Heidegger's philosophy is tainted by his association with Nazism has been a matter of controversy for decades. It provides, in any event, an unedifying spectacle.

concealment of the original Greek meaning. "The rootlessness of Western thought," Heidegger writes, "begins with this translation." Gosh.

But what about van Gogh? Let's take a look at the plate. Here we have a painting of a well-used pair of ankle-high leather shoes, half-unlaced, standing by themselves on a yellowish-orangish-brown surface. We all know what shoes are. Or do we? Heidegger urges us to look more closely. "The peasant woman wears her shoes in the field," he writes, "Only here are they what they are." (Hmm. What were they at night when they stood by themselves at the door? Best not to ask . . .) "A pair of peasant shoes," Heidegger tells us, "and nothing more. And yet—"

> From the dark opening of the worn insides of the shoes the toilsome tread of the worker stares forth. In the stiffly rugged heaviness of the shoes there is the ac-cumulated tenacity of her slow trudge through the far-spreading and ever-uniform furrows of the field swept by a raw wind. On the leather lie the dampness and richness of the soil. Under the soles slides the loneliness of the field-path as evening falls. In the shoes vibrates the silent call of the earth, its quiet gift of the ripening grain and its unexplained self-refusal in the fallow desolation of the wintry field. This equipment is per-vaded by uncomplaining anxiety as to the certainty of bread, the wordless joy of having once more withstood want, the trembling before the impending childbed and shivering at the surrounding menace of death.

And here you thought that van Gogh had just painted a pair of old shoes.

Heidegger is one of those writers whose more lyrical passages really demand a soundtrack to be fully appreciated—something . . . Teutonic: lush, heavy, sentimental, *mit Schlag*. But what an amazing scene he discovered in van Gogh's painting. It didn't happen by accident. It was, Heidegger says, "only by bringing ourselves before van Gogh's painting" and opening ourselves up to its inner meaning that we understand its depths. "This painting spoke. In the vicinity of the work we were suddenly somewhere else than we usually tend to be." (Indeed. Or should I say "thank God"?) Heidegger is very strict about paying close attention:

> The art work let us know what shoes are in truth. It would be the worst self-deception to think that our description, as a subjective action, had first depicted everything thus and then projected it into the painting. If anything is questionable here, it is rather that we experienced too little in the neighborhood of the work and that we expressed the experience too crudely and too literally.

In fact, there are one or two other questionable things that I might mention. Heidegger does not say exactly which of the eight paintings of shoes by van Gogh he had in mind in "The Origin of the Work of Art." But in response to a query from the art historian Meyer Schapiro, he wrote that the picture to which he referred was one he saw at an exhibition in Amsterdam in March 1930. As Schapiro notes in "The Still Life as a Personal Object—A Note on Heidegger and Van Gogh" (1968), the painting in question is clearly the

one illustrated earlier in this book. (Though Heidegger may have taken away the image of the sole from *Three Pairs of Shoes* [1886], which was exhibited at the same time and in which one shoe is turned over to expose a worn sole.)

I think everyone will applaud Heidegger's admonition to place oneself in an attitude of respectful attention before works of art and to be cautious about "projecting" merely subjective fantasies into paintings. The problem is that in his eagerness to see art as a setting-into-work of truth, Heidegger was a wee bit hasty in his description of van Gogh's painting. The evocation of the peasant woman trudging about the fields might strike you as edifyingly poetic; it might strike you as a piece of nauseating sentimentality. But in any case it has little pertinence to van Gogh's painting since, as Schapiro observes, the footwear in question are "clearly pictures of the artist's own shoes, not the shoes of a peasant." Which makes it difficult, one would think, to say that the painting expresses the "Being of beings," the "loneliness of the field-path," etc. "They are," Schapiro argues, "the shoes of the artist, by that time a man of the town and the city."

It may be a cheering thing to believe that "The art work let us know what shoes are in truth," but only if, as Heidegger acknowledges, we have not deceived ourselves—or, as he might put, we have not deceived ourselves about the nature and being of what is as it is. But Schapiro is right: "the philosopher has indeed deceived himself."

He has retained from his encounter with van Gogh's canvas a moving set of associations with peasants and

the soil, which are not sustained by the picture itself but are grounded rather in his own social outlook with its heavy pathos of the primordial and earthy. He has indeed "imagined everything and projected it into the painting." He has experienced both too little and too much in his contact with the work.

In short, Heidegger has enlisted van Gogh's picture into a philosophical scenario that has nothing to do with what van Gogh actually painted.

Schapiro asks an interesting question about and provides an illuminating supplement to Heidegger's description of van Gogh's painting of a pair of shoes. The question is what in Heidegger's "fanciful description . . . could not have been imagined in looking at a real pair of peasant's shoes"?

Think about it. Heidegger wants to claim immense ontological privilege for art: art as the setting-into-work of truth, etc. But couldn't he, just by looking a *real* pair of peasant shoes, spin the same story about the "rugged heaviness of the shoes," "the accumulated tenacity" of the peasant woman's trudge, the "the far-spreading and ever-uniform furrows of the field," the "dampness and richness of the soil," and all the rest—the vibrating but silent call, the ripening grain, the impending childbed, etc., etc.? Why would this fantasy be more substantial if occasioned by a painting than by a real pair of shoes— especially if one went to the trouble of assuring that the shoes in question were in fact well-worn women's shoes that had actually seen service in the field? This is an obvious question, but one that Heidegger never bothers to address.

Schapiro's illuminating supplement concerns the

place of those shoes in van Gogh's life. Van Gogh's paintings of shoes *are* remarkable. They have a mysterious loneliness about them. You can see why Heidegger was tempted into romance. But, as often happens, the real life story behind van Gogh's shoes is more moving than the fiction imposed upon them. When Gauguin shared a studio with van Gogh in Arles in 1888, he noticed van Gogh's old shoes. Schapiro quotes from Gauguin's recollections:

> In the studio was a pair of big hob-nailed shoes, all worn and spotted with mud; he made of it a remarkable still life painting. I do not know why I suspected that there was a story behind this old relic, and I ventured to ask him if he had some reason for preserving with respect what one ordinarily throws out for the rag-picker's basket.
>
> "My father," he said, "was a pastor, and at his urging I pursued theological studies in order to prepare for my future vocation. As a young pastor I left for Belgium one fine morning . . . to preach the gospel in the factories, not as I had been taught but as I understood it myself. These shoes, as you see, have bravely endured the fatigue of that trip."
>
> Preaching to the miners in the Borinage, Vincent undertook to nurse a victim of a fire in the mine. The man was so badly burned and mutilated that the doctor had no hope of his recovery. . . . Van Gogh tended him for forty days with loving care and saved the miner's life.

Even allowing for Gauguin's habitual embroidery, this moving story tells us something important about why

van Gogh would have lavished such attention on his footwear and that, in turn, contributes something to our appreciation of his paintings of shoes. It's not quite as electrifying as what Heidegger has on offer, but it does have the virtue of corresponding to some actual experience.

Verbal vertigo

Heidegger's high-flown variations on a theme by van Gogh may have precious little to do with van Gogh's art. His interpretations may also have set a profoundly bad example, encouraging generations of students to indulge in a gaseous conflation of art and a certain anemic species of godless religiosity. But at least Heidegger was in earnest. His speculations may be dense; they may be foggy; they may even veer painfully close to the ludicrous. But they were undertaken seriously. The same cannot be said for Heidegger's impish heir, Jacques Derrida. Heidegger undertook his interpretation of van Gogh's painting in order to say something about Being (capital letter, please!). Derrida devotes 130 pages of his book *The Truth in Painting* (1987) to Schapiro's response to Heidegger's speculations about van Gogh's painting.

Reading Derrida is like plunging from the sunshine into a darkened hallway hung with mirrors. It takes a while to get your bearings, and even then vertigo and a feeling of disorientation persist. Derrida opens his book with a section called "Passe-Partout." It's a passport to Oz. Someone tells him, "I am interested in the idiom in painting." "What," Derrida asks, "does he mean?"

Does he mean that he is interested in the idiom "in painting," in the idiom itself, for its own sake, "in painting" (an expression that is in itself strongly idiomatic; but what is an idiom?)?

That he is interested in the idiomatic expression itself, in the words "in painting"? Interested in words in painting or in the words "in painting"? Or in the words "'in painting'"?

One thing is clear: that Derrida is not interested in painting but only in "painting" (or do I mean "'painting'"?).

When he gets around to van Gogh's shoes, Derrida pretends to be tormented by the "problem" of whether the shoes are really a *pair* of old shoes as Heidegger blithely assumed. "—[W]hat makes him so sure that it's a *pair of* shoes? What is pair, in this case?"

—If the laces are loosened, the shoes are indeed detached from the feet and in themselves. But I return to my question: they are also detached, by this fact, one from the other and nothing proves that they form a pair. If I understand aright, no title says "pair of shoes" for this picture. Whereas elsewhere . . . Van Gogh speaks of another picture, specifying "*a pair* of shoes." Is it not the possibility of the "unpairedness" (two shoes for the same foot, for example, are more the double of each other but this double simultaneously fudges both pair and identity, forbids complementarity, paralyzes directionality, causes things to squint toward the devil), is it not the logic of this false parity, rather than of this false identity, which constructs this trap? The more I look at this painting, the less it looks as though it could walk.

But how about talk? The more Derrida looks at it, the more it looks as though van Gogh's painting might talk.

Heidegger chose van Gogh's painting as an example of art that reveals "truth setting itself to work." But since he didn't specify which particular painting he had in mind, wasn't his choice also a form of abandonment?

—Let's say that he puts it to one side, puts it down beside the present discourse. In any case, letting things drop takes time. The trajectory is twisted enough for more than one thing to happen in it. The moment he has "chosen" *the* picture, without choosing *among* the pictures in a series the existence of which he knows about, he abandons it. He begins, from the next sentence, to let it, if you like, drop: "But what is there to see here that's so important? (*Aber was ist da viel zu sehen?*)" What more is there, what is there that's so important, to see in this painting? The reply comes quickly and is clear-cut: *nothing*. Nothing that we didn't know already—outside the picture (by implication). This reply is never contradicted, but merely meditated on in the course of a winding road [*chemin en lacet*]. There will never appear a single content about which one could decide that, *qua* content, it belongs to the picture, is disclosed, defined, described, read *in* it. In these conditions, how could there be any confusion or projection with regard to the nature or property of painted things?

Would you care to venture an answer?

I cannot stress strongly enough that *every page* of Derrida is like this—a goulash of punning, pointless

abstraction. The result reminds one of the unfortunate protagonist of Hugo von Hofmannsthal's "Letter of Lord Chandos," the poor soul for whom language had disintegrated to the edge of unintelligibility. "My case, in short, is this," Hofmannsthal's character wrote:

> I have lost completely the ability to think or to speak of anything coherently. . . . Single words floated round me; they congealed into eyes which stared at me and into which I was forced to stare back—whirlpools which gave me vertigo and, reeling incessantly, led into the void.

The difference is that Hofmannsthal's character is aware of and recoils from his incoherence: Derrida embraces and celebrates his.

Jacques Derrida is one of the most adulated, highest paid, and influential academics in the world. What does that tell us? That celebrity is a license for un-bridled intellectual masturbation? In part. But it is worse than that. Figures like Michael Fried, David Lubin, Svetlana Alpers, and Griselda Pollock are not *exceptions* in the world of academic art history today. They and their many confrères *are* the academic es-tablishment: they define the heights of their discipline. It is they who set the trends, start the fads, shape the study of art history. Graduate students emulate them. Publishers chase them. And what, meanwhile, has happened to art?

Epilogue

There are more things in heaven and earth, Horatio,
Than are dreamt of in your philosophy.
—Hamlet I: v

Saving the appearances

IT WOULD have been a simple matter to make this
book twice as long. I could have turned to the
Marxist art historian T. J. Clark and his efforts to un-
derstand modernism as "tied to, and propelled by, one
central process: the accumulation of capital, and the
spread of capitalist markets into more and more of
the world." I could have included Cristelle Baskins's
meditations on Renaissance *Cassone* art in terms of
"the intersection of feminism, gender studies, art his-
tory, and postmodern critique." I could have dilated on
Michel Foucault's influential reading of *Las Meninas* as
"an essential void: the necessary disappearance of that
which is its foundation—of the person it resembles and
the person in whose eyes it is only a resemblance."
(Take a look at the plate of *Las Meninas*. What do we

have here: an "essential void" or a portrait of the Infanta Dona Margarita?) In short, when it comes to the rape of the masters, one is faced with an embarrassment of—well, if not riches, exactly, then at least examples.

I began this book by asking why we teach and study art history. The examples gathered in the preceding pages suggest that there are essentially two opposing answers. One answer—my answer—is that we teach and study art history to learn about art. The answer furnished by the academic art establishment is that we teach and study art history in order 1) to show how clever one is and 2) to subordinate art to a pet political, social, or philosophical agenda.

There is, by the way, no gainsaying the cleverness. It takes considerable ingenuity, after all, to conclude that the letter "i" with a circumflex equals a "fertilized female" which in turn equals a "circumcised female." (See above, page 94.) The question is whether such cleverness is fruitful and illuminating—or merely obfuscating.

Readers will have noted that my own interpretations of the paintings featured in *The Rape of the Masters* are simpler and more straightforward than the interpretations offered by the art historians I criticize. Which is also to say that my readings are considerably less ingenious. Is that a defect? I believe that Sargent's painting *The Daughters of Edward Darley Boit* is a group portrait of the daughters of Edward Darley Boit, not an allegory about "procreation, artistic as well as biological." Similarly, I believe that Courbet's painting *The Quarry* is a hunting scene not "a displaced and metaphorical representation of the activity, the mental

and physical *effort*, of painting." Which is the better approach?

In one of his essays on painting, Henry James observes that "There is a limit to what it is worthwhile to attempt to say about the greatest artists." I believe that is true of all art. The great occupational hazard for an art critic or art historian is to let words come between the viewer and the experience of art—to substitute a verbal encounter for an aesthetic one. As Clement Greenberg observed somewhere, art is "a matter of self-evidence and feeling, and of the inferences of feeling, rather than of intellection or information, and the reality of art is disclosed only in experience, not in reflection upon experience." The chastening truth is that most good art reduces the critic to a kind of marriage broker, a middleman between the viewer and the work of art. Often, the best thing a critic can do is to effect an introduction and then get out of the way.

There are several reasons for this. One reason has to do with what we might call the deep superficiality of aesthetic experience. The experience of art, like the experience of many human things, is essentially an experience of surfaces, of what meets the eye. When it comes to such realities, the effort to look behind the surface often results not in greater depth but in distortion. The philosopher Roger Scruton touched on this truth when he observed that "There is no greater error in the study of human things than to believe that the search for what is essential must lead us to what is hidden." This is the deep truth behind Oscar Wilde's quip that only a very shallow person does not judge by appearances.

My aim in *The Rape of the Masters* has been pri-

marily negative: to equip the reader with a nose for balderdash and absurdity. In one of his marvelous "Christmas Crackers," John Julius Norwich recounts the exhortation with which one John Alexander Smith, Waynflete Professor of Moral and Metaphysical Philosophy at Oxford, began a course of lectures in 1914.

Gentlemen, you are now about to embark upon a course of studies which will occupy you for two years. Together, they form a noble adventure. But I would like to remind you of an important point. Some of you, when you go down from the University, will go into the Church, or to the Bar, or to the House of Commons, or to the Home Civil Service, or the Indian or Colonial Services, or into various professions. Some may go into the Army, some into industry and commerce; some may become country gentlemen. A few—I hope a very few—will become teachers or dons. Let me make this clear to you. Except for those in the last category, nothing that you will learn in the course of your studies will be of the slightest possible use to you in after life—save only this—that if you work hard and intelligently you should be able to detect *when a man is talking rot*, and that, in my view, is the main, if not the sole, purpose of education.

I have quoted a lot of rot in this book. My hope is that readers will henceforth find it easier to identify, laugh at, and reject the rot that has infected the academic study of art history. That exercise in mental house-cleaning is valuable in itself, providing as it does a measure of resistance to the de-civilizing tendency of politically-motivated interpretive hyperbole.

There is also a subsidiary benefit, having to do with intellectual back-stiffening. In other words, I hope that *The Rape of the Masters* will provide some inoculation against academic intimidation. The claims made by the critical marauders I discuss in this book are so outlandish, and they are typically expressed in language that is so rebarbative, that many people are stunned into acquiescence or at least into silence. It pleases me to think that *The Rape of the Masters* will help counteract that anesthesia, prompting more people to object to the objectionable.

And this brings me to the positive aspect of my argument. Although *The Rape of the Masters* is hostile to the depredations practiced by criticism upon art, it aims at the same time to encourage the beneficent, pleasurable, civilizing elements that have traditionally been accorded to our encounters with good art. In one sense, this is a notably modest ambition, since it often happens that the most a critic can do is to remove the clutter impeding the direct enjoyment of art. True, that clutter sometimes includes the debris of ignorance or insensitivity, and in this respect art critics and art historians can provide useful guideposts that make it easier to see the work for what it is. But at bottom, their function is a humble one: to clear away the underbrush that obscures the first-hand apprehension of works of art.

Of course, this modest task has an ambitious corollary motive, namely to help restore art to its proper place in the economy of cultural life: as a source of aesthetic delectation and spiritual refreshment.

Acknowledgments

"Of making many books," wrote the author of Ecclesiastes, "there is no end," and I do not think he was particularly happy about it. At the same time, that estimable sage assures us that "there is a time to every purpose under the heaven," including, it must be thought, the expression of thanks. I wish in particular to register my thanks to Hilton Kramer, my friend and colleague at *The New Criterion* for more than (I am amazed to realize) twenty years. Mr. Kramer's own practice as a critic stands in sharp and exemplary contrast to the follies I have catalogued in this book. My own forays into criticism—and not just art criticism—would have been impossible without his example, his counsel, and his encouragement. It is a pleasure to acknowledge that debt.

I am also grateful to my other colleagues at *The New Criterion*, especially to James Panero, who witnessed the slow gestation of *The Rape of the Masters* with tact, humor, and numerous helpful suggestions. Others whom I wish to thank are J. Duncan Berry, James Franklin, Alexandra Kimball, and Richard Wattenmaker, all of whom provided helpful criticism, admonition, and editorial guidance. Then there are those few graduate students—you know who you are—who

acquainted me with some strikingly florid specimens of contemporary art-historical absurdity. I am grateful indeed for the introductions: they contributed much to the vividness of this pathologist's report. If I leave my beneficiaries nameless, it is only because I am aware that their academic careers might suffer from publicity.

The course of writing a book is seldom entirely smooth, but it often, I am told, proceeds more or less according to schedule. This book, alas, was an exception to that happy rule. For reasons too tedious to enumerate it was, like the Mad Hatter, late, late, for a very important date, namely its deadline. This inconvenienced several people, above all Peter Collier, my friend (still) and editor as well as the publisher, *genius loci*, and chief visionary of Encounter Books. I am grateful for his forbearance under pressure.

I have dedicated this book to William F. Buckley, Jr., a man who for more than half a century has been a beacon of sanity and good sense in the tempest of American cultural and political life. Mr. Buckley is someone whose energy, faith, intelligence, courage, and probity—not to mention his unfailing generosity and good cheer—are objects of admiration and reminders that "gentleman" is a designation that has not yet lost its pertinence. The number of people and institutions that he has benefited by his vivifying interest is extraordinary. *National Review* and "Firing Line," two of his best known initiatives, are only the tip of the iceberg. I am deeply grateful for his friendship and honored to be able to dedicate this book to him.

RK
March 2004

Notes

Introduction

6 On how political imperatives have affected the study of literature, see my book *Tenured Radicals: How Politics Has Corrupted Our Higher Education* (second edition, Chicago: Ivan R. Dee, 1998) and John M. Ellis, *Literature Lost: Social Agendas and the Corruption of the Humanities* (New Haven: Yale University Press, 1997).

6 "The instant the criterion . . ." Walter Benjamin, "The Work of Art in the Age of Mechanical Reproduction," in *Illuminations: Essays and Reflections*, edited and with an introduction by Hannah Arendt (New York: Schocken, 1968), page 224.

7 "paintings and other works . . ." Tom Wolfe, *The Painted Word* (New York: Farrar, Straus & Giroux, 1975), page 6; see also page 119.

9 On the origins and character of political correctness, see my essay "Political Correctness, or the Perils of Benevolence" in *The National Interest*, No. 74, Winter 2003/04, pages 158–165.

10 "and indeed Christian." John McEwen, "Maybe Not, but Still Art," *The Daily Telegraph*, 10 September 1995, page 6.

10 On "the trivialization of outrage," see my essay of that title in *Experiments Against Reality: The Fate of Culture*

in the Postmodern Age (Chicago: Ivan R. Dee, 2000), pages 277–304.

15 "strange affection . . ." Joseph Butler, *Fifteen Sermons Preached at the Rolls Chapel* (London: Macmillan & Co., 1913), page 16.

16 "It plainly does not follow . . ." David Stove, "Tax and the Selfish Girl or Does 'Altruism' Need Inverted Commas?" in *Darwinian Fairytales* (Aldershot: Avebury, 1995), page 92.

17 "It is not because . . ." Joseph Butler, *Fifteen Sermons*, pages 17 and 18.

17 "'Calvinists,' Stove observes . . ." David Stove, "Idealism: A Victorian Horror Story (Part Two)," in *Against the Idols of the Age*, edited by Roger Kimball (New Brunswick: Transaction Publishers, 1998), page 187.

17 "the worst argument . . ." David Stove, "Judge's Report on the Competition to Find the Worst Argument in the World," *Cricket Versus Republicanism and Other Essays* (Sydney: Quakers Hill Press, 1995), page 66.

18 "gastronomic idealism," Stove, "Idealism: A Victorian Horror Story (Part Two)," page 185.

18 "is common to . . ." Stove, "Idealism: A Victorian Horror Story (Part Two)," page 193.

19 "without reference to theory . . ." "All cultural practice . . ." Keith Moxey, *The Practice of Theory: Poststructuralism, Cultural Politics, and Art History* (Ithaca: Cornell University Press, 1994), pages xii and xiii.

20 "Derrida has shown . . ." *ibid.*, page 6.

22 "Only if it is possible . . ." *ibid.*, page 13.

23 "The abandonment of an epistemological . . ." "a form of political intervention. . ." *ibid.*, pages 23, 24.

23 "the processes of cultural . . ." *ibid.*, pages 24–25.

24 "a politically committed form . . ." *ibid.*, page 18.

24 "recognizing that politics . . ." *ibid.*, page 28.

25 "Instead of valuing . . ." *ibid.*, page 113.

25 "To suggest that signs . . ." *ibid.*, page 114.

26 "'genius' is a socially . . ." *ibid.*, page 146.

26 "Whether or not the artist . . ." *ibid.*

26 "ensured himself a place . . ." *ibid.*, page 147.

29 "refute a sickness," Friedrich Nietzsche, *The Case of Wagner* in *The Basic Writings of Nietzsche*, translated by Walter Kaufmann (New York: Modern Library, 1968), page 637.

31 "As a historical . . ." Otto Pächt, *Van Eyck and the Founders of Early Netherlandish Painting*, translated by David Britt (London: Harvey Miller Publishers, 1994), page 210.

31 "where art history is concerned . . ." quoted in Otto Pächt, *The Practice of Art History: Reflections on Method*, translated by David Britt (London: Harvey Miller, 1999), Preface.

32 "When we travel . . ." *ibid.*, page 19.

Chapter 1: Psychoanalyzing Courbet

33 "Since in everything . . ." Gerstle Mack, *Gustave Courbet* (New York: Alfred A. Knopf, 1951), page 10.

35 "unimaginable," Julius Meier-Graefe, *The Development of Modern Art: Being a Contribution to a New System of Aesthetics*, translated by Florence Simmons and George W. Chrystal (New York: G. P. Putnam, 1908), Vol. I, page 228.

35 "subtlety was his . . ." *ibid.*, page 219.

35 "a very great artist," "great fault was . . ." Clement Greenberg, "Review of an Exhibition of Gustave Courbet," in *Clement Greenberg: The Collected Essays and Criticism*, Vol. II, edited by John O'Brian, pages 276 and 278.

36 "M. Courbet produces . . ." quoted in Mack, *Gustave Courbet*, page 53.

36 "a vegetable fashion. . ." Meier-Graefe, *Development*, Vol. I, page 224. Meier-Graefe was paraphrasing Théodore Duret.

37 "crucial distinction . . ." Michael Fried, "Art and Objecthood," reprinted in *Minimalist Art: A Critical Anthology*, edited by Gregory Battecock (New York: E. P. Dutton, 1978), page 130. Italics omitted.

37 "theatre is now . . ." "theatre and theatricality . . ." "art degenerates . . ." *ibid.*, pages 125, 139, 141. Italics omitted from the last quotation.

38 "it is as though . . ." *ibid.*, pages 145–146.

39 "an actor," "effect and nothing . . ." "won the crowd," "What are the . . ." Friedrich Nietzsche, *The Case of Wagner* in *The Basic Writings of Nietzsche*, translated by Walter Kaufmann, (New York: Modern Library, 1968), pages 628, 629, 639, 636. Italics omitted.

39 "the special complicity . . ." Fried, "Art and Objecthood," page 127.

40 "the aesthetic alone . . ." Friedrich Schiller, *Letters on the Aesthetic Education of Man*, translated and with an introduction by Reginald Snell (New York: Frederick Ungar, 1981), page 103.

40 "Presentness is grace," "Art and Objecthood," page 147.

40 "He only thought . . ." Rosalind Krauss, *The Optical Unconscious* (Cambridge: MIT Press, 1993), page 266.

42 "allegory of its own . . ." "May be likened . . ." "propensity for calling . . ." "an archetype . . ." Michael Fried, *Courbet's Realism* (Chicago: The University of Chicago Press, 1990), pages 155, 137, 131, 258. In what follows, I draw partly on my discussion of Fried in Chapter 2 of my book *Tenured Radicals*.

43 "My argument can be . . ." *ibid.*, page 197.

43 "a representative male . . ." *ibid.*, page 189.

43 "eliminating the basis . . ." "the metaphorics of phallicism . . ." *ibid.*, page 190.

44 "can also be seen . . ." *ibid.*, page 193.

44 "The claims I advance . . ." *ibid.*, pages 48–49

45 "He had developed . . ." Jack Lindsay, *Gustave Courbet: His Life and Art* (New York: Harper & Row, 1973), page 148.

45 "great charm of . . ." Meier-Graefe, *Development*, Vol. I, page 239.

47 "another of Courbet's . . ." *ibid.*, pages 172–173.

48 "It follows . . ." *ibid.*, page 175.

49 "still another mode . . ." *ibid.*, 155.

49 "In place of the missing . . ." *ibid.*, page 174.

49 "I for one . . ." *ibid.*, page 174.

50 "The last observation . . ." *ibid.*, pages 174–175.

50 "My suggestion that . . ." *ibid.*, page 327.

52 "metaphysical meaning," *ibid.*, page 184.

52 "an absorptive thematics . . ." *ibid.*, page 182. This entire sentence is italicized in the original.

53 "I also believe . . ." Letter of December 25, 1861, reprinted in *A Documentary History of Art*, Volume III, selected and edited by Elizabeth Gilmore Holt (New York: Doubleday, 1966), page 352.

Chapter 2: Inventing Mark Rothko

58 "first-class walls . . ." quoted in Anna Chave, *Mark Rothko: Subjects in Abstraction* (New Haven: Yale University Press, 1989), page 6.

60 "I'm not interested . . ." *ibid.*, page 13.

60 "Abstract art never . . ." interview with William Seitz, 1952; quoted in Chave, *Mark Rothko*, page 25.

60 "You might as well . . ." an interview with Seldon Rodman, 1957. Quoted in Chave, *Mark Rothko*, page 25.

61 "only that subject . . ." *ibid.*, page 18.

62 "what is there in what we . . ." Hilton Kramer, "Was Rothko an Abstract Painter?" in *The New Criterion*, Vol. 7, No. 7, March 1989, pages 1–2.

63 "set out to paint . . ." Peter Selz, *Mark Rothko* (New York: The Museum of Modern Art), 1961. The entire essay, with commentary by Sidney Geist, is reprinted in *Scrap* 4, February 16, 1961 under the title "'moodily dare': IFP."

64 "Eventually as other . . ." quoted in *Scrap* 4, page 3.

65 "the notion that . . ." Chave, *Mark Rothko*, page 15.

66 "can be shown . . ." *ibid.*, page 3.

66 "My purpose is . . ."
 ibid., page 38.

67 "Rothko's art may . . ." "whether Rothko would . . ."
 ibid., pages 37 and 30.

67 "A glancing reference . . ." *ibid.*, pages 133–134.

68 "would be blatant distortion . . ." *ibid.*, page 160.

68 "Those images of Rothko's . . ." *ibid.*, page 161.

71 "incandescent color . . ." "bold and simple . . ."
 "asserts decorative elements . . ." Clement Greenberg
 "'American-type' Painting," *The Collected Essays and
 Criticism*, Vol. 3, page 232.

Chapter 3: Fantasizing Sargent

73 "For him . . ." Stanley Olson, *John Singer Sargent: His
 Portrait* (New York: St. Martin's Press, 1986), page 61.

74 "had no friends . . ." Olson, *Sargent*, page 6.

74 "by introspection or . . ." Olson, *Sargent*, page 52.

75 "uniform superficiality . . ." "transparently honest . . ."
 Roger Fry, "J. S. Sargent as Seen at the Royal Academy
 Exhibition of his Works, 1926, and in the National
 Gallery," in *Transformations: Critical and Speculative
 Essays on Art* (London: Chatto & Windus, 1926), pages
 173–174.

75 "worked his way . . ." Olson, *Sargent*, page 205.

75 "I have vowed . . ." "Ask me to paint . . ." *ibid.*, pages
 227 and 228.

76 "agreeably uncomplicated," *ibid.*, page 97.

76 "a deep genuflection . . ." *ibid.*, page 98.

78 "eminently unconventional . . ." "When was the pinafore
 . . ." Henry James, "John S. Sargent," reprinted in *The
 Painter's Eye*, pages 222–223.

78 "a literary picture . . ." Olson, *Sargent*, page 98.

80 "originated in . . ." David M. Lubin, *Act of Portrayal: Eakins, Sargent, James* (New Haven: Yale University Press, 1985), page ix.

80 "the inevitability of . . ." Lubin, *Act of Portrayal*, page x.

82 "whether Sargent meant . . ." *ibid.*, page 4.

82 "eerily dwarfed . . ." "prisoners in Bentham's . . ." "These girls are . . ." *ibid.*, pages 94, 107, 95.

83 "can be seen . . ." *ibid.*, page 95.

83 "Alice and Nora . . ." *ibid.*, page 95.

84 "repressed homoerotic . . ." "were filled with . . ." *ibid.*, page 20.

85 "Portraiture was a . . ." *ibid.*, page 20.

87 "She must be viewed . . ." *ibid.*, page 86.

87 "forms a sort of . . ." *ibid.*, page 86.

88 "form an oval . . ." *ibid.*, page 90.

89 "The painting offers . . ." *ibid.*, page 92.

90 "*The Boit Children* . . ." *ibid.*, page 97.

90 "Another way of . . ." *ibid.*, page 107.

91 "Sargent's portrait . . ." *ibid.*, page 108.

91 "It far oversteps . . ." "if somehow a psychic transfer . . ." *ibid.*, page 99.

92 "What are the differences . . ." *ibid.*, pages 108–109.

93 "The circumflexed *i* . . ." *ibid.*, pages 110–111.

94 "î = fertilized female . . ." *ibid.*, page 111.

94 "One looks, naturally . . ." Ronald Knox, *Essays in Satire* (London: Sheed and Ward, 1936), pages 224–225.

95 "The implication is . . ." "Astounding—impossible! . . ." *ibid.*, pages 228 and 229.

95 "We are encountering . . ." Lubin, *Act of Portrayal*, page 115.

95 "is thus . . ." *ibid.*, page 113.

96 "did not set . . ." *ibid.*, page 113.

Chapter 4: Inebriating Rubens

97 "the unfortunate and . . ." Kerry Downes, *Rubens* (London: Jupiter Books, 1980) page 3.

98 "the most learned . . ." Christopher White, *Peter Paul Rubens: Man and Artist* (New Haven: Yale University Press, 1987), page 79.

99 "Possibly more than . . ." White, *Rubens*, Preface.

99 "the Apelles of . . ." White, *Rubens*, page 79.

100 "that indefinable thing . . ." Eugène Delacroix *The Journal of Eugène Delacroix*, translated by Walter Pach (New York: Crown Publishers, 1948), page 595.

100 "belongs, certainly . . ." Henry James, "Les Maîtres d'Autrefois," *The Painter's Eye*, page 119.

100 "pictures always put . . ." quoted in Svetlana Alpers, *The Making of Rubens* (New Haven: Yale University Press, 1995), page 135.

101 "finished what Dürer . . ." H. W. Janson, *History of Art: A Survey of the Major Visual Arts From the Dawn of History to the Present Day* (New York: Harry N. Abrams, 1971), page 421.

101 "carried the image . . ." quoted in Peter C. Sutton, *The Age of Rubens* (Boston: Museum of Fine Arts, 1993), page 40.

102 "those little sileni . . ." Plato, *Symposium*, 215a.

103 "to die soon . . ." Friedrich Nietzsche, *The Birth of Tragedy* § 3.

103 "One of the most . . ." White, *Rubens*, page 55.

103 "As for me . . ." White, *Rubens*, page 74.

104 "stands apart . . ." *ibid.*

105 "a man of the market . . ." "*pictor economicus . . .*" "making art into . . ." "commodifie[d] himself . . ." Svetlana Alpers, *Rembrandt's Enterprise: The Studio and the Market* (Chicago: The University of Chicago Press, 1988), pages 88, 107, 109, 118.

105 "Rubens's own sense . . ." Svetlana Alpers, *The Making of Rubens*, page 101.

106 "how did Rubens . . ." "fixation . . ." *ibid.*, pages 101 and 106.

106 "a wellspring . . ." *ibid.*, page 143.

106 "a surprising number . . ." *ibid.*

106 "directly related . . ." *ibid.*, page 109.

107 "My sense is . . ." *ibid.*, page 112.

107 "There is no . . ." Christopher Brown, "Drunk, but Inviolate," *The Times Literary Supplement*, March 8, 1996, page 24.

108 "Protean in a . . ." "Men undone by . . ." Alpers, *The Making of Rubens*, pages 147 and 151.

109 "an effect . . ." *ibid.*, page 118.

109 "the kinship Rubens . . ." *ibid.*, page 141.

109 "What is disturbing . . ." *ibid.*, pages 139–140.

111 "The massive, naked . . ." *ibid.*, page 110.

111 "buggery as such . . ." *ibid.*, page 168.

112 "A more plausible . . ." Brown, "Drunk, but Inviolate," page 24.

112 "is anything but . . ." Hilton Kramer, "The Postmodern Assault," in *The Future of the European Past*, edited with an introduction by Hilton Kramer and Roger Kimball (Chicago: Ivan R. Dee, 1997), page 183.

Chapter 5: Modernizing Winslow Homer

115 "He got it all . . ." Jean Gould, *Winslow Homer: A Portrait* (New York: Dodd, Mead & Company, 1962), page 10.

117 "perfect realism . . ." Henry James, "On Some Pictures Lately Exhibited," *The Painter's Eye: Notes and Essays on the Pictorial Arts*, selected and edited by John L. Sweeney (London: Rupert Hart-Davis, 1956), page 96.

117 "practical, self-contained . . ." Philip C. Beam, *Winslow Homer at Prout's Neck* (Boston: Little, Brown, 1966), page 3.

118 "The problem with Homer . . ." Sarah Burns,
 "Modernizing Winslow Homer," *American Arts
 Quarterly*, vol. 49, No. 3, 1997, page 625.

118 "practically no life . . ." Greenberg, *Collected Essays*, Vol.
 1, page 235.

121 "addresses the same . . ." Nicolai Cikovsky, Jr. and
 Franklin Kelly, *Winslow Homer* (New Haven: Yale
 University Press, 1995), page 371.

120 "a streak in him . . ." Greenberg, "Review of an
 Exhibition of Winslow Homer," *Collected Essays*, Vol. 1,
 page 235.

121 "a hurricane *and* . . ." Gordon Hendricks, *The Life and
 Works of Winslow Homer* (New York: Harry Abrams,
 1979), page 250.

121 "powerful and superb . . ." quoted in Hendricks,
 Winslow Homer, page 251.

121 "unique burlesque . . ." *ibid.*, page 170.

122 "You ask me . . ." quoted in Hendricks, *Winslow Homer*,
 page 250.

122 "a great dramatic . . ." quoted in Beam, *Winslow Homer
 at Prout's Neck*, page 170.

122 "an almost Schopenhauerian . . ." Cikovsky and Kelly,
 Winslow Homer, page 383.

123 "The sharks in . . ." *ibid.*, *Winslow Homer*, page 379.

123 "Homer's fear . . ." *ibid.*

123 "It is almost . . ." Burns, "Modernizing Winslow Homer,"
 page 636.

124 "stylistic attributes . . ." "complex . . . and paradoxical
 . . ." Peter H. Wood, "Waiting in Limbo: A Reconsidera-
 tion of Winslow Homer's *The Gulf Stream*" in *The
 Southern Enigma: Essays on Race, Class, and Folk
 Culture*, edited by Walter J. Fraser, Jr. *et al.* (Westport, CT:
 Greenwood Press, 1983), pages 78 and 77.

125 "subconscious sensitivity," *ibid.*, page 84.

125 "North American artists . . ." Albert Boime, "Blacks in
 Shark-Infested Waters," *Smithsonian Studies in American
 Art*, Vol. 3, No. 1, Winter 1989, page 19.

125 "an allegory . . ." Boime, *ibid.*, page 36.

126 "'Here,' he says, . . ." *ibid.*, page 41.

126 "Homer's conspicuous . . ." *ibid.*, page 43.

127 "Homer's ironic tone . . ." *ibid.*, page 44.

128 "progressive," *ibid.*

128 "It is quite difficult . . ." "caustic irony . . ." "darkey pictures," Burns, "Modernizing Winslow Homer," page 625.

128 "Mr. Homer's pictures . . ." James, "On Some Pictures Lately Exhibited," page 91.

Chapter 6: Fetishizing Gauguin

129 "Inca blood . . ." George T. M. Shackelford, et al., *Gauguin Tahiti* (Boston: MFA Publications, 2004), page 4.

130 "*mal élevé*" Belinda Thomson, *Gauguin* (New York: Thames and Hudson, 1987), page 12.

130 "get on with . . ." Richard Brettell, et al., *The Art of Paul Gauguin* (Washington, D.C.: The National Gallery of Art, 1988), page 3.

130 "I try to confront . . ." *ibid.*

131 "study and ultimately . . ." Quoted in Griselda Pollock, *Avant-Garde Gambits: Gender and the Color of Art History*, page 12.

131 "strange, tortured . . ." W. Somerset Maugham, *The Moon and Sixpence* (New York: Penguin Books, 1977), page 6.

131 "a new art . . ." Shackelford, *Gauguin Tahiti*, page 18.

132 "I'm leaving so . . ." *ibid.*, page 19.

132 "Tahitian *noa noa* . . ." Paul Gauguin *Noa Noa: Gauguin's Tahiti*, edited and introduced by Nicholas Wadley, translated by Jonathan Griffin (Salem, New Hampshire: Salem House, 1985), page 37.

132 "My life is now . . . ," "Oceania [has been] . . ." Shackelford, *Gauguin Tahiti*, page 25.

132 "did not understand . . ." Clement Greenberg, "Review of Exhibitions of Paul Gauguin and Arshile Gorky," in *Clement Greenberg: The Collected Essays and Criticism*, Vol. II, ed. by John O'Brian, page 78.

133 "I told him that . . ." Pollock, *Avant-Garde Gambits*, page 76.

133 "fat, vicious . . ." *ibid.*, page 7.

134 "suggestion through . . ." Robert Goldwater, *Symbolism* (New York: Harper & Row, 1979), page 2.

134 "*Peindre, non la chose . . .*" *ibid.*, page 75.

134 "don't copy nature . . ." *ibid.*, page 78.

135 "shackles of verisimilitude" Herschel B. Chipp, et al., *Theories of Modern Art: A Source Book by Artists and Critics* (Berkeley: University of California Press, 1968), page 65.

135 "the essence of . . ." Goldwater *Symbolism*, page 203.

135 "no such thing . . ." Brettell, *The Art of Paul Gauguin*, page 15.

135 "frankly, Gauguin does . . ." Greenberg, *ibid.*, page 78.

136 "a brilliant resumé . . ." quoted in Brettell, *The Art of Paul Gauguin*, page 279.

137 "the Olympia of Tahiti . . ." Thadée Natanson, "Expositions: Oeuvres Récentes de Paul Gauguin," *La Revue blanche* Vol. 5, No. 26, page 421.

137 Gauguin, *Noa Noa*, pages 25–26.

138 "the musical part . . ." quoted in Brettell *The Art of Paul Gauguin*, page 281.

138 "attracted by a . . ." quoted in Pollock *Avant-Garde Gambits*, page 27.

139 "underlying guilt . . ." *ibid.*, page 68.

139 "is a representation . . ." *ibid.*, page 35.

140 "the distorting lens . . ." *ibid.*, page 10.

140 "The reality is . . ." *ibid.*, page 72.

140 "political and personal . . ." *ibid.*, page 10.

140 "In a post-colonial . . ." *ibid.*, page 9.

140 "How does a European . . ." *ibid.*, page 8.

141 "calculated career strategies . . ." *ibid.*, page 12.

141 "Gauguin's big stake . . ." *ibid.*, page 17.

141 "[i]n Gauguin's work . . ." *ibid.*, page 47.

142 "Teha'amana's presence . . ." *ibid.*, page 48.

143 "the structure of . . ." "racist implications . . ." *ibid.*, pages 28 and 26.

144 "in many ways plausible . . ." Stephen F. Eisenman, *Gauguin's Skirt* (New York: Thames and Hudson, 1997), page 19.

144 "is an image . . ." "savage androgyny . . ." Eisenman, *Gauguin's Skirt*, page 92 and 115.

145 "non-dimorphic sexual . . ." "a form of drag . . ." Eisenman, *Gauguin's Skirt* pages 95 and 98.

Chapter 7: Deconcealing van Gogh

147 "than in any . . ." Ingo F. Walther and Rainer Metzger, *Vincent van Gogh: The Complete Paintings* Vol. 1: Etten, April 1881–Paris, February 1888 (Berlin: Benedikt Taschen, 1990), page 241.

148 "the art work opens . . ." Martin Heidegger "The Origin of the Work of Art," in *Poetry, Language, Thought*, translated and with an introduction by Albert Hofstadter (New York: Harper & Row, 1971), page 39.

149 I offer my own thoughts about Heidegger's association with Nazism in "Heidegger at Freiburg, 1933" in *The New Criterion*, Vol. 3, No. 10, June 1985, pages 9–18.

150 "The rootlessness of . . ." Heidegger "Origin," page 23.

150 "The peasant woman . . ." *ibid.*, page 33.

150 "A pair of peasant . . ." *ibid.*, pages 33-34.

151 "only by bringing . . ." *ibid.*, page 35.

151 "The art work let . . ." *ibid.*, pages 35-36.

152 "clearly pictures of . . ." Meyer Schapiro "The Still Life as a Personal Object—A Note on Heidegger and Van Gogh" in *The Reach of Mind: Essays in Memory of Kurt Goldstein*, edited by Marianne L. Simmel (New York: Springer Publishing Company, 1968), page 205.

152 "They are," *ibid.*

152 "the philosopher has . . ." *ibid.*, page 206.

153 "fanciful description . . ." *ibid.*

154 "In the Studio . . ." *ibid.* page 208.

155 "I am interested in . . ." Jacques Derrida, *The Truth in Painting*, translated by Geoff Bennington and Ian McLeod (Chicago: The University of Chicago Press, 1987), page 1.

156 "—[W]hat makes . . ." *ibid.*, page 259

156 "—If the laces . . ." *ibid.*, pages 277–278

157 "—Let's say that . . ." *ibid.*, page 328.

158 "My case, in short . . ." Hugo von Hofmannsthal, "The Letter of Lord Chandos" *Selected Prose of Hugo von Hofmannsthal*, translated by Mary Hottinger (New York: Pantheon Books, 1952) pages 133, 134–5.

Epilogue

159 "tied to, and . . . T. J. Clark, *Farewell to an Idea: Episodes from a History of Modernism* (New Haven: Yale University Press, 1999), page 7.

159 "the intersection of . . ." Cristelle L. Baskins *Cassone Painting, Humanism, and Gender in Early Modern Italy (Cambridge: Cambridge University Press, 1998)*, page 25.

159 "an essential void . . ." Michel Foucault *The Order of Things: An Archaeology of the Human Sciences* (New York: Random House, 1973), page 16.

161 "There is a limit . . ." Henry James, "Les Maîtres d'Autrefois," *The Painter's Eye*, page 118.

161 "There is no greater . . ." Roger Scruton "The Classical Vernacular: Architectural Principles in an Age of Nihilism" (New York: St. Martins Press, 1994), page 41.

162 "Gentlemen, you are . . . ," quoted in John Julius Norwich, *More Christmas Crackers* (London: Viking, 1990), page 14.

Index

Only books and articles mentioned in the text are indexed. Other titles are cited in the endnotes.

Roger Kimball is Managing Editor of *The New Criterion* and an art critic for the London *Spectator* and *National Review*. His previous books include *Tenured Radicals: How Politics Has Corrupted Our Higher Education*; *The Long March: How the Cultural Revolution of the 1960s Changed America*; *Experiments Against Reality: The Fate of Culture in the Postmodern Age*; *Lives of the Mind: The Use and Abuse of Intelligence from Hegel to Wodehouse*; and *Art's Prospect: The Challenge of Tradition in an Age of Celebrity.*